ISBN 978-1-330-56859-0
PIBN 10079867

For support please visit www.forgottenbooks.com

1 MONTH OF
FREE
READING

at

www.ForgottenBooks.com

———◇———

By purchasing this book you are eligible for one month membership to ForgottenBooks.com, giving you unlimited access to our entire collection of over 700,000 titles via our web site and mobile apps.

To claim your free month visit:

www.forgottenbooks.com/free79867

FRENCH FOLLY

IN

MAXIMS

OF ART

Translated and Edited by

HENRI PÈNE DU BOIS

New York

BRENTANO'S

PREFACE.

The public! How frightful the word is! It is much more frightful‘ than the thing itself. For the public is all powerful in favor of or against the mercantile artist who in art sees only commerce. It may, if it wishes, fill the purse of this business man. But the public can do nothing, either for or against the sincere artist whom only love of the true and the beautiful guides, and to whom glory itself is only an accessory aim. This artist depends on his peers, and on posterity, which alone can judge definitely.

We should not let words amaze us. I do not like the famous imprecation against the public which Fernand Desnoyers wrote. He called the public, " Beast with the head of a

calf, a rabbit, and a snake!" I do not like it, because it lacks measure. Even in lyrical poetry one should be polite. Then the poet could not have drawn that sort of a head. If it is a calf's head, it cannot be a rabbit's; and if it is a calf and rabbit head, it cannot be at the same time a snake's. Nevertheless, if the artist's anger is expressed in an empyric form it is not the less legitimate.

Somebody has said that the public had more wit than Voltaire. I do not believe this. I think that the public has not as much wit as a dunce. It likes silly works and the silliest songs, and burns incense at the feet of ugly idols.

Yet, endless are the platitudes that even men of genius have said in favor of the public. How servilely Molière bent before it, every poet who has read the prologue to "Amphitryon" sadly knows. He did not believe a word of this infamous prologue, but his excuse

is that he had to feed a particularly ravenous company of players.

Artists are not in his predicament. They may, and they must, dispense with the public. They, and they only, are great magicians enough to give to a modern sovereign the costume of Cæsar Augustus.

Universal suffrage never created a celebrity. Whenever it had the air of creating the glory of an individual, the glory lasted for a day.

None may be judged but by his peers. This action of civil law is always true, but it is still truer in art. Posterity can do nothing but ratify the verdict of an artist's peers. As for the immediate judgment of an artist's contemporary public, it always finds its way into the lumber-rooms with old clothes and old moons.

Public! You may enrich whom you will, crowd a sumptuous playhouse or a circus tent, and buy the painted canvases of this or of that workman. But you can do nothing more.

You have not a twig, nor a leaf, of the laurel that winters do not kill. You have not it, and you cannot give it.

All the hypocritical prefaces in which blind success is glorified rest on a willful, deceptive confusion of these two beings: Public and People. The people is easily moved. It is sincere, illuminated, by the divine light of instinct, quick at understanding art and rule because it is a workman in the trades. It may be impressed by the absolutely beautiful. But the public cannot assimilate the beautiful.

What is the public? A crowd, an accidental assembly of all sorts of people in places too high-priced for representatives of the people and of elevated minds. The public is not at all instinctive. It is more rich than learned, and its education is always inferior to its social situation.

The public has an abiding faith in politics, in committees, in Congressional debates. The

people has the same indifference for these things that St. Francis of Assisi expressed. It does not in the least care to know who holds the handle of the pan in which it is frying.

The public is intoxicated by words, complicated laws, and all sorts of things that cost nothing, and which are not good to eat. The people does not care for incoherent figures.

The public, ever seduced by sentimental and false ideas, likes the comfort of hospitals, charity, fairs for the poor, and all the expressions of philanthropy which permit society to mingle with comedians and to disguise themselves into dairy-maids.

The people detests hospitals, and the entire apparel of charity appears to it to be a means of eluding, or of extinguishing with weak installments, an imperious debt which will have to be paid some day.

The public is a born stockholder, and gives good gold in exchange for green-tinted paper.

Artists need not convince, nor fear, nor flatter the public. If they be good enough workmen to be regarded as such by their peers, and if they have not the fatuity to expect any-thing from posterity; if their works are sincere, truthful, and not decked with false jewels, they may earn enough to buy a gown once a year for their wives. What more do they want? A simple artist need not, like Vanderbilt, have a special cook for each dish of his meals.

The unique condition of good art is to give to the delicate among the people something for which they are always hungry: sincerity. Be sincere! There is no other rule. There is no other system. All the teachers who have taught differently have deceived you.

All men of genius have been sincere. There are no schools in art, there are only individu-als. Every man of genius is necessarily an individual, an isolated being, precisely because

sincerity is his only rule and that none may borrow from him his manner of being sincere.

Imitators **are** naturally lazy and cowardly. They begin by reducing to a convention, to a formula which it is horribly easy to apply, the things that they imagine are the processes of a master. Now, a master has no process. His only rule is to observe as exactly, as naively as possible, nature, life, and the human mind. His means of expression are as varied as are his infinite and diversified sensations. His imitators are consequently his worst enemies. They are his contrary, and they are not at all of his school.

If we are sincere in criticism as well as in invention, we shall have to acknowledge that men of genius, from the mere fact that they exist, have delivered the world from convention and formula.

Sincere—everybody wishes to be, everybody

would be, if the demon of the commonplace did not always lead one to the summit of a mountain and promise, and honestly give, all the kingdoms of earth in return for his cult.

It is enough, in order to obtain all the material riches, honors, and rewards, for the artist to flatter the sempiternal Philistine prejudice and confuse art with morality. Art and morality have nothing in common.

The world, as it is, asks only one thing: It asks that it shall be painted as it is not. Feign to see it as it pretends to be and it will open to you all the caverns of the Rajahs.

Morality in art! Think of it! Apply the formula, and what wretchedly inferior works are the Iliad and the Venus of Milo! Art and morality! It is vainly that the spider's web has been torn by the spur of every passing cavalier. Academies on the pedestals of their monuments place the figure not of Art, but of

Wisdom, as if it were ever wise to do anything other than the thing which is to be done.

The true artist creates men and women. He does not please the public, but he holds all the people who think.

A work of art expresses the mind of its workman. In it are clearly reflected his vices and his weaknesses. He may deceive men, perhaps, but not inspiration, which shall not be duped by his hypocrisy.

An artist must be simple, kind, enthusiastic, ardently in love with the beautiful, humble and naive.

David de la Gamme, often quoted in this book, is called a Pre-Raphaelite when he writes over another signature, which I am not to reveal. I owe to him everything that I know. It is not much, but such as it is, it is his. He is not a Pre-Raphaelite.

Paul Verlaine, for the Digression of whom I

am indebted to Philip Zilcken and to the tire-less kindness of Mr. S. P. Avery, is the great poet of the present time.

<div align="right">

HENRI PÈNE DU BOIS.

</div>

MAXIMS OF ART.

I.

There is really beautiful only the useless.

Théophile Gautier

II.

That life may be grand one must put in it the past and the future. Our works of poetry and art must be accomplished in honor of the dead and with the thought of those who are to come after us.

Anatole France.

III.

It is a crime to efface the successive impressions made on stone by the hand and mind of our ancestors. New stones carved in old style are false witnesses.

Ibid.

IV.

Art is aristocratic or nothing.

Edouard Pailleron.

V.

Art makes no concessions, it imposes them.

Ibid.

VI.

In art the great trick is not to do better, but to do otherwise.

Ibid.

VII.

Beware of an artist who talks too well of his art. He wastes his art in talk.

Ibid.

VIII.

To an artist usurers are terrible, but woman is worse.

Ibid.

IX.

In the first place work. Have talent and you shall have success.

Edouard Pailleron.

X.

Art was aristocratic yesterday, it is democratic to-day, and consequently subject to universal suffrage and its necessary disgraces.

Ibid.

XI.

Have success and there shall always be fools to say that you have talent.

'bid.

XII.

To love, for an artist, is perilous. To marry, to put into the secret of his work, that is of his efforts, of his doubts, and of his discouragements, a woman who believes in him as in God, and imagines that to create a solemn gesture is sufficient for him as for God, this is an irreparable fault.

Ibid.

XIII.

There are wives for artists, as for poets, actors, military men, and even state ministers.

Edouard Pailleron.

XIV.

The moral of art : beauty.

Edmond et Jules de Goncourt.

XV.

Woman, when a masterpiece, is the greatest art object.

Ibid.

XVI.

Summit of the ` absolutely beautiful : the Torso of the Vatican.

Ibid.

XVII.

Courbet's painting—the ugly, always the ugly, the ugly without character, without the beauty that there may be in the ugly.

Ibid.

XVIII.

Art is the " eternization " in a supreme force absolute and definite, of the " fugitivity " of a creature or of a human being.

Edmond et Jules de Goncourt.

XIX.

There is a wearisome beauty which resembles a pensum of the beautiful.

Ibid.

XX.

Ideas of healthy democracy have facilitated independent opinion in matters of art. Art criticism has not now its former pedantic tone. It misinforms the public, but it condemns nobody to death.

Ary Renan.

XXI.

I prefer silence rather than music.

Théophile Gautier

XXII.

Music is a noise costlier than other noises.

Ibid.

XXIII.

Books are not written to be read aloud.

Théophile Gautier

XXIV.

Never has a virgin, young or old, produced a work of art.

Edmond et Jules de Goncourt.

XXV.

Art is not one, or rather there is not only one art. Japanese art has its beauties like Greek art. At bottom what is Greek art? It is realism of the beautiful, with nothing of the ideality preached by the art teachers of the institute. In Greek beauty there is neither dream, nor fantasy, nor mystery.

Ibid.

XXVI.

The genius of horror is the genius of Spain.

Ibid.

XXVII.

The beautiful is simple.

Paul de St. Victor.

XXVIII.

The marvelously white marble of the Pantheon is as black as ebony.

Gustave Flaubert.

XXIX.

In the nude, painted, sculptured, or described, some see only the line of the beautiful; others see always temptation.

Edmond et Jules de Goncourt.

XXX.

The beautiful is something which appears abominable to the uneducated.

Ibid.

XXXI.

The beautiful is what your servant instinctively thinks is frightful.

Ibid.

XXXII.

The seductive trait of a work of art is always in ourselves. Who knows if all our impres-

sions of exterior things come not of these things, but of ourselves. There are sunny days which seem gray to the mind, and gray skies which one recalls as the brightest in the world. The quality of wine is in the glass, the instant, the place, the table where one drinks it. The beauty of woman is in the love which looks at her.

Edmond et Jules de Goncourt.

XXXIII.

Blue is a color whereof azure is the dream, and it is light which of that reality makes this ideal.

Catulle Mendès.

XXXIV.

The canvas where beauty is to be shaped is, to the artist, no more a piece of stuff than for the faithful priest the tabernacle where God is to come is wood.

Ibid.

XXXV.

No painting is equivalent to the invisible reverse of the canvas.

Ibid.

XXXVI.

The artist is like a royal prisoner who, in his cell piteously closed with iron shutters, lights a thousand torches: colors whereof the blind panes of glass should be illuminated—but on the other side there **is** the light of the sky.

Catulle Mendès.

XXXVII.

One becomes disgusted with art objects when one considers the people who own them, with women, when one considers those whom they have loved, and with social circles when one considers those who are received in them.

Edmond et Jules de Goncourt.

XXXVIII.

The idea is inseparable from the sentiment, the sentiment from the sensation, from language of lines, or colors, of lights and shades which are immediate realizations.

Sèailles.

XXXIX.

The art of painting is perhaps more indiscreet than any other. It is an indubitable testimony to the moral state of the painter at the instant that he held the brush

Eugène Fromentin.

XL.

There are a thousand ways of seeing the same object.

Jules Lemaître.

XLI.

The body has a character as complex and as difficult to comprehend as the moral character whereof it is the translation and the symbol.

Ibid.

XLII.

There is no still life since I have looked at the vase which I painted with eyes that are human.

Eugène Carrière.

XLIII.

How vain is painting which attracts admiration by resemblance to originals that we do not admire.

Blaise Pascal.

XLIV.

Art and life are under different conditions. Art is fed on the excessive, life exacts activity without shock or violence.

Paul Flat.

XLV.

It is impossible to mark in history the epoch where an art finishes, the epoch where another art commences.

M. Beulé.

XLVI.

Great nations are not more easily explained than great men.

Ibid.

XLVII.

Architecture has been the teacher of all the other branches of art.

M. Beulé.

XLVIII.

Art is the intervention of the human mind in the elements furnished by experience.

Ibid.

XLIX.

To work in the same manner as the master, to copy and make over again the work that he had done, was the first sentiment of artists. Thus they appropriated the patrimony of the past and profited by the expierence of the generations which had preceded them. . . . That is why all the monuments in Greece have a family air.

Ibid.

L.

The Greeks had the justest intelligence of art ; they knew that the works of men endure only by beauty of form, and that the most

beautiful thought is nothing if the expression which translates it is not still more beautiful

<div align="right">*M. Beulé.*</div>

LI.

The modern spirit is in direct opposition with the antique spirit. The ancients thought of form before everything; we think of thought before everything.

<div align="right">*Ibid.*</div>

LII.

In criticising an architectural work, do not think of the theoretical explanations until after you have searched in vain for the material explanations.

<div align="right">*Ibid.*</div>

LIII.

The first condition necessary to appreciate and to produce good painting is to have cultivation.

<div align="right">*H. Taine.*</div>

LIV.

All real talent is tact.

H. Taine.

LV.

Arts of design require a soil not too highly cultivated.

Ibid.

LVI.

People of wit never have so much wit as when they are together. To have works of art, you need in the first place artists and also studios.

Ibid.

LVII.

Flemish painting is brilliant only in qualities distinct from intellectual qualities.

Charles Baudelaire.

LVIII.

The arabesque drawing is the most ideal of all drawings.

Ibid.

LIX.

Music digs heaven.

Charles Baudelaire.

LX.

The beautiful is something ardent and sad, something vague, lending a field to conjecture.

Ibid.

LXI.

A beautiful woman's head is one which makes one dream, in a confused manner, half pleasure and half sadness.

Ibid.

LXII.

To create a commonplace is to have genius.

Ibid.

LXIII.

Germany expresses reverie with lines, England with perspective.

Ibid.

LXIV.

Music gives the idea of space.

Charles Baudelaire.

LXV.

The rôle of elevated industries is not to counterfeit but to innovate.

A. Jacquemart.

LXVI.

Even when the genius of artists rests on pre-existing ideas or is inspired by ideas of another age or of other countries, it must transform them by impressing upon them the seal of its individuality, and by making them applicable to the manners and to the conventions of its time.

Ibid.

LXVII.

Fashion disturbs at once gowns and furniture, and even architecture.

Francis Aubert.

LXVIII.

One would be surprised to learn how a sovereign, an artist, a banker, or even an ordinary woman in evidence, can by her temperament and her preferences for reform, by her manner of seeing things, by a particular taste in fine, change everything around her.

Francis Aubert.

LXIX.

The supreme law of art, harmony, or unity in variety must be applied to every form of art.

Ibid.

LXX.

There are no beautiful creations in presence of which one may not feel an emotion of mingled joy, admiration, and surprise.

Ibid.

LXXI.

The painter is guided by nothing except his judgment.

Nestor Roqueplan.

LXXII.

The purely mechanical portion of the art of the tapestry-weaver may be learned in a year.

Nestor Roqueplan.

LXXIII.

Study of creations of art of glorious epochs teaches us that every work of art must be in harmony not only with received ideas but also with independent artistic ones.

Paul Mantz.

LXXIV.

This utilitarian and mercantile epoch applies all its efforts to diminishing fatigue and pain.

Auguste Luchet.

LXXV.

In art, this epoch destitute of enthusiasm has the faculty to reproduce and to imitate whatever it pleases with a perfection that no other epoch ever attained.

Ibid.

LXXVI.

One never invents anything, one only repeats ;
but one may marvelously improve.

Auguste Luchet.

LXXVII.

The old lives and the new is dead.

Ibid.

LXXVIII.

Ancient works make one warm, modern
ones leave one placid. The reason is, perhaps,
that the ancients had more faith than we have.

Ibid.

LXXIX.

Certainly to copy with exactness is some-
thing, but to invent is better.

Paul Mantz.

LXXX.

The impression produced on man by a beau-
tiful work is made of surprise, admiration,
sympathy, love, desire, and, generally, joy.

Francis Aubert.

LXXXI.

If it is melancholy that predominates in the emotion produced by a work of art, the reason is that the work is sublime.

Francis Aubert.

LXXXII.

To make an impression on new minds beauty must be transcendental.

Ibid.

LXXXIII.

The law of conventions must dominate all the conceptions of the artist. If it did not, Mæcenas would hesitate to surround himself with objects the utility of which should be more apparent than real.

A. Jacquemart.

LXXXIV.

The best-trained eye could not replace science of proportions,

A. de La Roque.

LXXXV.

All the arts the end of which is not immediate reproduction of nature, such as music, poetry, and architecture, owe their processes to physical laws the exactitude of which is mathematical.

A. de La Roque.

LXXXVI.

Ask of a spring only the water it can give, and thank Heaven for it.

Francis Aubert.

LXXXVII.

In searching for severity many have found ennui.

Paul Mantz.

LXXXVIII.

Something will remain of this passing epoch that the future discounts and that interest squanders This is workmanship. It was never more admirable.

Auguste Luchet.

LXXXIX.

What is taste? Nobody knows. It is, per-
haps, the soul.

Auguste Luchet.

XC.

The epochs which never violated the laws of
decorative convention in art are those which
were the grandest.

Ernest Chesneau.

XCI.

Nothing so well reflects the intimate thought
of a sculptor as the earth which he has shaped
under his fingers.

J. Grangedor.

XCII.

To be faithful to one's inspiration, to the
ardors of one's temperament, to the fancies of
one's imagination, and, at the same time, to
obey the best and the healthiest traditions of
decorative art, is to give a true proof of strength
in grace and of respect for oneself and others.

Ibid.

XCIII.

To-day, more than ever, when it is the fashion to be skeptical, allegory is in disfavor.

Francis Aubert.

XCIV.

Does not everybody know that in the picture of a colorist all is nothing but illusion ?

J. Grangedor

XCV.

In painting all is convention; in decorative art all is reality.

Ibid.

XCVI.

If the artist limits himself to the transcription of a reality which is before his eyes, if he is resigned to be a decorator or an entertainer, his works may interest amateurs, but they shall never evoke a sympathetic echo in any artist's mind.

Ernest Chesneau.

XCVII.

The modern artist lives isolated, surrounded by a crowd which does not understand him.

A. de La Roque.

XCVIII.

All arts are obscured, filled with vanities and useless artifices, through the maliciousness of professors.

Gaspard de Saulx.

XCIX.

Will, faith, and patience, on the three a ray of sunlight—such is genius.

Auguste Luchet.

C.

Landscape is, from the point of view of pure æsthetics, the true complement of man.

Ernest Hache.

CI.

It is easy to steal success, to surprise the public either by stereotyping an impression or by juggling with the grotesque or the impossible.

Ernest Hache.

CII.

If you wish to fix the solar spectrum, retire into the dark room.

Ibid.

CIII.

Nothing resists art more effectively than the commonplace black coat.

Ibid.

CIV.

Nothing is easier than to be conventional about the Orient.

Ibid.

CV.

The classic landscape is to painting as is tragedy to letters.

Ernest Hache.

CVI.

A sacred forest may be a forest, although sacred.

Ibid.

CVII.

All artists really strong are kinsmen.

Ibid.

CVIII.

Modern industry is justified, in advance, in using all processes to apply them to works of any style.

Alfred Darcel.

CIX.

It is sweet to say, " What a great painter I might have been ! "

Théophile Gautier.

CX.

One may look at gods, kings, pretty women, and great poets without disturbing them.

Théophile Gautier

CXI.

It is seldom that an artist may be known by his first and charming aspect. Fame comes to him only when the fatigues of life, struggle, and tortures have altered his primitive physiognomy.

Ibid.

CXII.

It is more difficult to be a great poet than to be a great painter.

Ibid.

CXIII.

Of all arts, the one which lends itself least to the expression of the romantic idea is assuredly sculpture.

Ibid.

CXIV.

Sculpture received from antiquity its definite form.

Théophile Gautier.

CXV.

What can a sculptor do without the gods and the heroes of mythology?

Ibid.

CXVI.

Every sculptor is necessarily classic.

Ibid.

CXVII.

Every sculptor is naturally of the same religion as the Olympians.

Ibid.

CXVIII.

Sculptors are generally physically strong.

Ibid.

CXIX.

Color should not seem to one to be culpable sensuality.

Théophile Gautier

CXX.

There is a quality which is rare in art : force.

Ibid.

CXXI.

Every beautiful work is a germ planted in April which will bloom in October.

Ibid.

CXXII.

To be young, intelligent, to love and to commune in art, is the most beautiful manner of living.

Ibid.

CXXIII.

To fall from heaven it is necessary to have gone there, if only for an instant, and this is

more beautiful than to crawl on earth during one's entire life.

Théophile Gautier

CXXIV.

An artist of middle age should not review the opinions and the women whom he loved at twenty.

Ibid.

CXXV.

Poetry is not a permanent state of the soul.

Ibid.

CXXVI.

The poet is the only artist who cannot be laborious.　His work does not depend on him.

Ibid.

CXXVII.

The idea that a poet may be exclusively a poet and live on his work may not be defended.

Ibid.

CXXVIII.

The artist has no place in modern civilization.

Théophile Gautier

CXXIX.

Real artists have no other professors than themselves.

Ibid.

CXXX.

The French school of art has for its principal qualities wisdom, clearness, soberness, philosophic composition, correct drawing; but it satisfies reason more than the eyes.

Ibid.

CXXXI.

The aim of art is not exact reproduction of nature, but creation, by means of forms and colors, of a microcosm wherein may be produced dreams, sensations, and ideas inspired by the aspect of the world.

Ibid.

CXXXII.

The romantic painters have sought for everything which will distinguish them from Philistines.

Théophile Gautier

CXXXIII.

Happy is the man who has produced one great painting, if only one!

Ibid.

CXXXIV.

Life does not always keep its promise, but art has never deceived us.

Ibid.

CXXXV.

If by chance fortune comes to the threshold of an artist who has drunk until then from the cup of the ideal only, he goes at once to a skillful goldsmith for his champagne silver pails,

Ibid.

CXXXVI.

The goldsmith works only for emperors, popes, kings, princes, and the fortunate people of the world.

Théophile Gautier

CXXXVII.

The Greeks have forever determined the laws, the conditions, and the ideal of art.

Ibid.

CXXXVIII.

It is painful for a composer to write, for a poet to feed his poetry with his prose, for a painter to pay for his pictures with his lithographs; in a word, for an artist to live of the trade of his art.

Ibid.

CXXXIX.

In art, as in reality, one is always somebody's son.

Ibid.

CXL.

There are poets of twenty whose works are forty years of age.

Théophile Gautier

CXLI.

It is rare that a poet can distinguish wheat from barley.

Ibid.

CXLII.

One may love, admire a master and be devoted to him without ever copying him.

Ibid.

CXLIII.

The poet should see human things as a god would see them from Mount Olympus.

Ibid.

CXLIV.

The poet should reflect the things that he sees without personal interest in them.

Ibid.

CXLV.

The mission of art is to give to things the superior life of form.

Théophile Gautier

CXLVI.

The Greeks of Marseilles, who inhabit a golden bank, between the double azure of heaven and sea, are familiar with the antique at their birth.

Ibid.

CXLVII.

One needs a rare philosophy and a very pure love of art to work in the shadow.

Ibid.

CXLVIII.

There are poets who have talent and even genius, and do not ever write great poems.

Ibid.

CXLIX.

The most difficult thing to understand in painting is a solitary figure.

Ibid.

CL.

Poetry is a prodigal, like nature.

Théophile Gautier.

CLI.

The visionary eye of the poet knows how to disengage the phantom from the object and to mingle the chimerical with the real in proportions which are poetry itself.

Ibid.

CLII.

In a dream of ideal Gothic architecture, in a choir opened on the sky, with fourteen niches framed with twisted columnettes of red marble, crowned with leaves of stone, are young smiling women, allegories of virtues and of sciences dressed in virginal colors, and on whom fall softened lights—this is a work of Taddeo Gaddi.

E. et J. de Goncourt.

CLIII.

You are not an artist if you have not earned the hatred of fools.

Théodore de Banville.

CLIV.

THE HATRED OF FOOLS.

With his great comedy in verse, in five acts, "The Infanta," produced at a Palmer matinée, the poet won a triumph such as had not been heard of in years. He became radiant at once in full glory. All the play-houses wanted plays from him, all the magazines sent blank contracts to him which he had only to fill, and editors and publishers of newspapers crowded his drawing-room as do the flowers of May a garden. If he wished, he might have thought that he was a great man, and tried on his brown head a hat made of laurel leaves. But on the contrary, he was not confident, even a week after ward when he went to New Rochelle to see his old friend, Prof. Glardon.

As he entered the studio, vast, warm, and intimate, wherein one's mind receives calmness and joy, he was glad that the master had gone out because it gave him time to collect his thoughts. The servant was dressing the table, which is of the Francis I. epoch and carved with the representation of a dance of nymphs and of fauns.

The poet looked at two heavy easels on which were paintings of Helen of Sparta, tall, superb, with her calm, starlike visage, walking in the moonlight in the plains of Troy, near the river which rolled its waves reddened by the blood that had been spilled for her. The other canvas showed under a furious sun a figure of natural size, a breaker of stones, whose face was hideous and savage but resigned.

As he was admiring these two works, Prof. Glardon came in. He is vigorous, gigantic, as strong as an oak, with eyes of somber gray, admirably kind, energetic, and brave. He shook the hands of the poet with tender effusiveness and said:

"Nobody could have been as happy as I am at your success."

"At my success only!" said the poet anxiously.

"Yes, but what does it matter? I know only color tubes and brushes. I am an old man, trying to reproduce effects of color that only the initiated may understand, and I know no more about poems than the passer-by."

"Oh! Like masters of the sixteenth cen-

tury you might build palaces and cathedrals, fortify cities, construct aqueducts, chisel jewels, model a Colossus, and if you wished, write sonnets like Michael Angelo. Alas, my comedy did not please you ! ”

“ But, why should I be forced to tell you the truth ? Truth is a very inconvenient goddess, good only to soil one’s carpets with dripping water. She comes out of a well, you know. Her first duty is to dry herself, her second is to put on a veil.”

As he was talking, a tall young girl, pale as a lily, her heavy gilt chestnut hair brushed back without ornament, entered, bowed, and seeing that there were brushes uncleaned began to wash them with black soap.

“ Well,” continued Prof. Glardon, “ your work was too near to perfection and too far from life. Women cried and smiled, the public applauded, the press unanimously celebrated you, but you have not had the only consecration which is not deceptive, the only serious promise of a laurel crown, the only praise which has any value.”

“ What is that ? ” asked the poet.

" Hatred of fools ! " said Prof. Glardon.
" It never errs. If you haven't it, you have
nothing. All the rest may be appearances, lies,
and illusions. It may be that women were
charmed because the wind was east and that
the men were gay because the actress has a pug
nose. Semi-artists may have been made en-
thusiastic by the appearance of perfection and
timid people by the applause of your friends.
The press may praise you because your talent
is honorable enough. But the hatred of fools
is like paradise. You shall not obtain it if
you have not earned it a hundred times in
thoughts, words, and acts."

David de La Gamme.

CLV.

The tendencies of the coming epoch shall be
dissimilar in art.

Georges Lecomte.

CLVI.

The art of the future may be more philo-
sophic and more intellectual

Ibid.

CLVII.

A mysterious, dreamy art of painting may come after the present standard reproductions of nature.

Georges Lecomte.

CLVIII.

Nature disengaged by the impressionists from all contingency, interpreted into logical harmonies of tones and of lines, gives, besides plastic joy, intimate emotions of an intellectual order.

Ibid.

CLIX.

The annunciators of the art of the future that is, of mystic art, are not as great innovators as they think they are.

Ibid.

CLX.

The new-comers in art do nothing but continue systematically a long evolution.

Ibid.

CLXI.

I have been subjected to various transformations. I have had the Prix de Rome. I have produced in marble busts of Themistocles and statues of Abundance, which the government has bought and which have ornamented public gardens. There are stupid trades. But I quitted the commonplace years ago. I studied drawing under Monet and Degas—yes, sir, Monet and Degas—and these two great men have taught me how to reproduce instantaneously a movement, an impression, the expression of a face, and to make exact sketches as rapid as the flying moments.

David de ˈa Gamme.

CLXII.

It is not easy to write the Iliad, but it is not easier to create paper dolls which will talk without talking.

Ibid.

CLXIII.

To question humbly and resolutely the human face is the only way of obtaining what

modern writers call human documents. There never was any other way. Chambermaids lie, young women who confide to you their reminiscences had read them in bad novels; but eyes, a nose, a mouth are bound to tell the truth if it be asked of them. Lines are forcibly sincere, and even the face of the Joconda says, " I lie."

David de La Gamme.

CLXIV.

Every face talks the better when it talks without saying anything.

Ibid.

CLXV.

There is no instance of a man who devoted his life to a cult for Shakespeare and remained an ordinary man.

Philoxène Boyer.

CLXVI.

Book lovers were always art lovers. The thought of circulating libraries impresses them as painfully as would the thought of circulating

the stained-glass windows, the images carved in wood, the statues of the kings of Israel, or the paintings, or the ornaments on the columns of the cathedral of Amiens.

David de La Gamme.

CLXVII.

An artist may place in a work only his mind. If his mind be pure, filled with love for mankind and ardently in sympathy with elevated ideals his work shall be admirable.

Ibid.

CLXVIII.

Exaltation of the best in everything is the significance of art. It demands religious inspiration, since genius is not logical, has only perception, and reaches its highest flights in moments of pure ecstasy.

Ibid.

CLXIX.

One should salute with joy the dawn of new art, because it is not proper that new-comers

should be the slaves of the formulas of their elders.

Georges Lecomte.

CLXX.

You may be seduced by all the chimerical systems which mediocrity invented to make of dramatic art an art of pure legerdemain. But read a page of Shakespeare and these vain ideas will vanish from your mind like light clouds.

David de La Gamme.

CLXXI.

In the most respectable galleries impressionists' pictures have taken their place by the side of the masterpieces of other times. Slowly the education of the public has been formed.

Georges Lecomte.

CLXXII.

Twenty years of strong works have made those who mocked the impressionists hush. The least informed of critics acknowledges that the evolution has been accomplished.

Ibid.

CLXXIII.

We are not far from the time when comic operas, operettas, and burlesques made fun of the great impressionists' paintings.

Georges Lecomte.

CLXXIV.

Impressions received from one site vary infinitely, according to the intensity ˙and the tone of the astral diffusion.

Ibid.

CLXXV.

One motive, ceaselessly repeated in modified forms by the height of the sun in the sky, shall be a pretext for very dissimilar effects.

Ibid.

CLXXVI.

There is no fashion in the art of expressing nature as it is.

Jules Claretie.

CLXXVII.

Paul Potter has nothing to fear from the severity of the future, because he has yielded nothing to the passing craze.

Jules Claretie.

CLXXVIII.

As modern apartments are somber people want paintings in clear colors.

Charles Jacque.

CLXXIX.

If the passion for books might be attenuated, if this love which never decreases might be deceived, this would be done assuredly through philosophic observation of the vanity which lurks in this religion, which, like all religions, has false priests and false followers.

Octave Uzanne.

CLXXX.

If at any moment of your life you ever had the slightest shade of a thought that nudity was immoral, or that painting a picture was a way

of earning wealth, or fame, or simple considera-
tion, or that art had any other object than to be
art, drop your palette. Be a Philistine, for that
is your temperament.

David de La Gamme.

CLXXXI.

It is not a crime to be a Philistine.

Ibid.

CLXXXII.

SERVE GOD OR MAMMON.

In Grove Street the passers-by usually stop in
surprised admiration before the grille of a paved
corridor which leads to a house the front of
which is made almost entirely of glass. It is the
property of a painter, and it was bequeathed to
him by a very old unmarried woman whom
Aaron Burr and Washington Irving, people say,
had courted; but one must not put too much
faith in what people say.

Miss Ellen and her father are surrounded by
the esteem of their neighbors, and they live in
retirement; yet they often have visits of illustri-

ous persons, of politicians who ask advice of his implacable common sense, and of great artists who were his pupils and have not ceased to regard him as their master. These have no illusions about their triumphs if they have his supreme approval. One of them stepped out of an elegant hansom cab the other day and listened for an instant to the notes of an organ playing in the studio.

Too impatient to wait till the music had ceased he pulled the knob of the bell and, the door opening of itself, walked through the corridor and passed into the vast studio. Miss Ellen was playing a prelude by Bach. In the silence, in the noble harmony of the severe surroundings, this prelude executed by the tall young girl similar to a Muse, and whose features, illuminated by interior ecstasy, were resplendent, had a truly celestial character, and her father and the visitor relished a few of the rare instants when vile terrestrial preoccupations are unknown and minds are filled with light. When the music ceased, Miss Ellen affably bowed to the visitor and retired. Her father lit his old black pipe and offered a cigar to his former

pupil; but, although his manner was cordial, he said nothing.

"Perhaps you have observed," the visitor said timidly, "my ardent and respectful admiration for Miss Ellen. I did not dare to confess to myself a sentiment which from day to day has grown stronger. I imagined I was not worthy enough, but you know what my present situation is. . "

"My dear boy," the old painter replied, softly, "you know that Ellen and I are in perfect communion of minds. She has not a thought that she conceals from me. I know that she does not wish to be married."

"You are not selfish enough," said the visitor, "to accept a sacrifice which she would make for you if she wished to marry and gave you the impression that she did not. It is evident that my proposal is rejected by her as well as by you, and I am convinced that my work does not please you. What faults have you found in my last picture?"

"My rheumatism keeps me at home," said the old man. "I did not see your exhibition."

"O!" said the visitor, in a tone at once re-

spectful and irritated, "I saw you there and I know that you looked at it."

"Well," replied the old man severely, "you see that I wish to be as if I had not seen it. I have not to criticise your work, and my praise is of no value to you. So let us drop the subject and be friends. You have money, fame, and, probably, a great deal of talent. Art is not what it was once, and a street Arab has forgotten more than Plato ever knew."

, "Yes, but not more than Zeuxis or Phidias," said his pupil. "You were my master; tell me the truth."

"I might observe," said the old man, "that I have rarely seen you in years, that in the interval untruth has been sufficient for you, and that you have known very well how to live without my advice. But it shall not be said that you have invoked my frankness in vain. Your Venice is neither a goddess, nor a woman nor anything else! She smiles like a wax figure, she has neither muscles, nor lines, nor forms; her movement is that of a living picture at Koster & Bial's; she poses in a lapis-lazuli and opal landscape powdered with mica, and

the ridiculous children that are flying around her are made of stuffed satin. You paint so skillfully that you succeed in placing nothing on your canvas. It is neat, pretty, clever, false. In fine, you have deserved the ignominy of being adored by society people."

"Oh!" the visitor exclaimed indignantly.

"Yet," continued the old man, " you might be sincere if you wished. I consent to accept mythology, but you should reflect that in the modern conception òf it Aphrodite is a gigantic force whose celestial purity nothing may tarnish, that she is a formidable divinity, and that the desires which are created by her must be beautiful and vivid. Do you wish to make of her a woman? You may, for the human figure contains everything; but let her head be proudly poised on her heroic and strong neck; let her breast be of flesh; let her arms be graceful enough to enchant minds and to overthrow lions. To think that I have known you a child of genius, wanting everything, capable of everything!"

The visitor's eyes were filled with sadness. He said, " Will you give me one other lesson?"

The old man replied, " Yes, but it will be the last. I am so old now. Anthony," he shouted to a model who was waiting in an adjoining room, " put on your clothes and come here."

Then he rolled into the light an easel on which was placed a small canvas representing a scene of suffering among striking cloak-makers. His pupil wished to express admiration, but the old man hushed him with a gesture and said :

" No, do not punish me for my frankness by complimenting me. I do not like praise. Look at this model. Tony is ugly, but how wittily and vividly ugly. Don't make of him a juvenile comedian. Remember that I taught you to reproduce instantaneously a gesture caught in the street ; remember that a muscle is a being, that the least inflection expresses life, and that fugitive impressions are to be determined by force of will and of love."

Under the master's eye the visitor, transfigured, resuscitated, become himself again, worked obstinately for three hours. During this time the old man modeled a sketch in clay and Ellen read aloud verses of Dante.

" My child," exclaimed the old man, " you are great again. This is a masterpiece ! "

" Well," said Ellen in a voice which was sonorous and firm, " quit your false glory, stay here and work ! "

He hesitated. Everything in the studio appealed to his heart. He had grown in this environment, wherein he knew that truth resided. But he thought of his triumphs, of his happy, envied, brilliant life, and bent his head. " No," he said, " I have not the cour-age."

" Then go," said Ellen, whose face expressed only contempt, and who, without a glance at the visitor saying good-bye at the door, resumed in silence her reading of Dante.

David de La Gamme.

CLXXXIII.

In art there are no schools, there are only individuals.

Ibid.

CLXXXIV.

It is imperatively necessary to paint nature from nature and not reminiscences.

Ibid.

⸤CLXXXV.

Do not torture your mind in quest of abstract beauty; be content with the beauty that is in a landscape or an attitude.

David de La Gamme.

CLXXXVI.

Be sincere.

Ibid.

CLXXXVII.

Sincerity is easily said, but it is not easily practiced. Innumerable lessons learned are in its way.

Ibid.

CLXXXVIII.

What one feels is altered in its instantaneous expression by what one has read or admired elsewhere.

Ibid.

CLXXXIX.

If one imagine that resemblance in portraits be absolute and uniform, how mistaken the idea is!

Ibid.

CXC.

The same subject may serve for radically different portraits, all relatively truthful.

David de La Gamme.

CXCI.

Light, moods, innumerable accidents make model and painter infinitely varied.

Ibid.

CXCII.

A portrait reflects its creator as much as its theme.

Ibid.

CXCIII.

A painter cannot imitate a characteristic without recreating it.

Ibid.

CXCIV.

A portrait painter must have instinctive sagacity, sureness of view, imagination, and the intuitiou of a poet.

Ibid.

CXCV.

There are psychological portraits in which every trait is subordinated to moral expression; there are mundane portraits which are clear and expressive, but less profound than graceful; there are portraits expressive without familiarity, individual and vivid, but generalized in careful regard to form.

David de La Gamme.

CXCVI.

Thinkers and observers will certainly rejoice in the possession of the vivid and sincere impressions of illustrious, or simply curious, figures of the present time. One may wish that artists of to-day who have renounced the cold madrigals of ancient landscapes might replace also in their real life the distinguished figures of the past.

Ibid.

CXCVII.

Doubtless the age in which we live is a Shylock. It has lent, in the guise of money, its youth, its ardor, its incessant labor, and it re-

quires in exchange its pound of flesh. Epi-
gram-makers say that this pound of flesh the
women whom modern painters idealize have
not.

David de La Gamme.

CXCVIII.

The old masters of Holland amaze one by
the minuteness of their exactitude.

Ibid.

CXCIX.

It would be heresy not to be enthusiastic
about the old masters; yet one may not hesi-
tate to turn from them to the most recent
works.

Ibid.

CC.

It is not because they proscribe ochre and
brown colors that the impressionists are mod-
ern.

Ibid.

CCI.

Every great artist has his habits, his repetitions, his grimaces, and they are no more his genius than a mole is a face.

David de La Gamme.

CCII.

One should accept everything—yellow trees, Venices floating in mist, seas pale blue striated with gold, coats blacker than ink—everything except imitations of imitations.

Ibid.

CCIII.

As nature is infinite, diverse, eternally variable, unexpected, and disconcerting, the real artist understands that he must at every moment create new modes of expression. What living creation suggests, the things that happen in his mind, the emotions that succeed one another within him with amazing swiftness, are to be immobilized by him by means that experience cannot teach. In such moments he is not a workman, but one inspired. Imitate him honestly and your painting will not resemble

any work that he ever produced, and it will be as great as his masterpiece.

David de La Gamme.

CCIV.

Statues, like. words, should be used in right places. Otherwise they are solecisms.

Jean Pierre.

CCV.

There is nothing in the world except art.

David de La Gamme.

CCVI.

SERVE ART OR EROS.

Perfect community of ideas unites a painter and a comedian. The comedian transfigures himself into Ben Butler, Bismarck, or anybody else, whenever he wishes. The painter gives animation to the frigid crowd of the painted figures and makes them live like the human crowd created by Shakespeare. When the comedian, completing with the most lucid intuition documents that he had patiently gathered,

forms the definite conception of a historical personage, the painter summarizes his work for him in a portrait audacious and true, which the comedian will copy.

A week ago, the comedian observed that the painter's work was not as good as it might have been, and so he called on his friend, determined to learn the reason of his weakness. Really, the painter was apparently the prey of mortal despair.

" Well," said the comedian, opening the door of his friend's room, " your Russian princess——"

" You may tell me to shut the door against her. I have done it, but Vera has twenty-four hours every day to herself and lots of millions for her whims. She finds a way of sending to me, through the keyhole I suppose, flowers which I throw away and letters that I never read, for I have no pen, and I will agree to do anything except write. I am not a Jewish savior of Egypt, although the part that I am playing is as ridiculous as was his, but a Princess, a woman in society—think of evening dress, useless phrases, and money which is so

necessary for stuffs, models, furniture and arms, and armor! The golden pupils of her eyes beseech me constantly; I know that there is for me no respite from them. I think that I might as well obey her and work afterwards!"

"No," shouted his friend in a tone of anguish, "for 'afterward' has no existence in fact. You would never be an artist again. Listen! There is only art, the rest is nothing. The women we know must be, as we are, strangers to the world. You are a great man, do not become useless. Promise to obey me."

The painter placed himself at the comedian's mercy. The latter acquired the air, the face, and the expression of the painter so exactly that a mother would have been deceived. Then he went to the Russian princess's house. He passed through drawing-rooms ornamented with carpets of the Orient. She was draped in tender-colored stuffs. He said not a word. He covered her with kisses more numerous than planets in a starry sky, realizing her dream in the fullness of its ambitious programme, under the pale light of an alabaster lamp

She called the servant, lighted the golden candelabra and looked at her conqueror. For an instant he was the painter still, but suddenly he wished to be the comedian again, and Vera had a fine attack of rage, anger, and violence. But the comedian reasoned with her.

" My friend the painter," he said, " has no time to express anything but painting. He has a world in his head, he has no leisure for love. You love him; prove it to him—leave him alone ! "

<div align="right">

David de La Gamme.

</div>

CCVII.

The night was clear, but the painter's mind was calmer and more serene than the white winter night, wherein the moonlight and the rays of the stars made their spirits dance on the frozen earth. He was in his smiling room, tapestried with stuffs of silk and of wool, with linen and velvet. He was seated in his arm-chair before his hearth and doing absolutely nothing. He was smoking a cigarette, a ciga-rette with a blue crest that deserved a poem in short stanzas printed on cigarette paper.

Everything in the room was flaming: statuettes, crystal glasses, and vases of King-Te-Tchin. He nonchalantly listened to the domestic harmonies as if he were at the opera and had not to take the trouble to applaud. In the flames of the fire sang and danced, to the tune of triangle and castanets, a Salamander dressed in gold and silver stuffs and metallic paper covered with all sorts of spangles. Her jewels of Venice, her glass beads, her veils of pink and blue crepe studded with tin stars turned in the dazzling rainbows of the coals.

"I love you," she said. "Really! I am as graceful as the comets, I am as dazzling as Fred Mortimer's prose, and I sing like a series of triolets threaded with pearls in a necklace. I love you because you truly prefer to see me dance rather than to look at Carmencita in the company of fifteen hundred fools. This is to be a fairy spectacle, in comparison with which the spectacle wherein Amelia Glover danced with thirty-two thousand diamonds on her, not counting her eyes, was insignificant indeed. And the lighted lanterns in fantastic flames said:

" ' We are the planets and the stars of your home, and it is for you that we dance. Our gowns are orange-colored and we are as red as cherries. We are not like our thin sisters who whiten their cheeks to please Burne-Jones. We love you because you are wise and never, never go to a regimental fair.' "

David de La Gamme.

CCVIII.

The more I looked at it, the less I could detach my eyes from this charming face. I could not say how profoundly it evoked in me ideas of profound calmness, of painful voluptuousness, of mysterious rest in a room embellished with all the refinements of luxury and of elegance. This face had not only beauty, but the incisive charm of strangeness which leads one into an abyss of dreams. Around her forehead, which was low, large, and powerfully modeled, hair of Arachnean fineness, curled and short at the front as in portraits of the eighteenth century, formed a golden mist. The eyes, too large, of burnished gold, framed by large eyebrows rigorously straight and by a

fringe of black lashes, showed in their illumi-
nated pupils a heaven of stars and of magic
sparks. The lips were of unheard-of beauty and
impressed one like poems of joy.

It seemed to have been drawn, not with
colors, but really with imagination and light, for
on this enchanted canvas nothing revealed
patient successive work and the coarseness of
material means. It was an impression and a
painter's vision.

The owner tried to lead me to other paint-
ings of his collection. but I said, "No, the
masters whose works are gathered in your gal-
lery may think what they wish. I declare, in
advance, without having seen them, that this
face is greater than all their works. Imagine a
man who has read the psalm of psalms and to
whom you offered another poem by some un-
known versifier. Do you think he would ex-
change for it his vision of beating wings,
towers of ivory, roses in bloom, tall lilies, lov-
ing forms, and perfumes among cedar-wood
furniture and stuffs ornamented with embroid-
ery?"

"But my Rembrandt, my Hobbema, my

authentic Raphael, my Murillo, which all the museums of Europe envy——"

" Have no existence in fact," I said. " The painter of this portrait was twenty years of age it is evident."

" He was in love, somebody loved him, the great cry of the poets carried his mind in the stars, the admiration of the masters transported him with patient fervor. At this moment there was not a human fear which he could not have chased like a pearl in the most precious carvings. Alas, he is to-day bald-headed, a member of the National Academy of Design, and I suppose that he paints battles of Fredericksburg as large as a table of forty covers.

" Yes, the story of his life is as ordinary, but it deserves to be told, because it demonstrates the infirmity of incomplete genius, wherein the creative faculty does not reign absolutely like a tyrannical queen."

" Yes," I said, " the Muse of painting is the most jealous, the most intolerant of mistresses. She does not want hearts that do not belong to her entire. The gift of conceiving and of translating the beautiful is incompatible with

all human passion, for everything human is imperfect and the objects of our desires attract us by their imperfections; that is why our mind loses in vain attachments the power to rise to immortal beauty, immortal beauty which suffers no contact with the material. I suppose that your artist fell in love'?"

"Yes," he said, "he was an artist and yet he fell in love."

David de La Gamme.

CCIX.

Individually the arts have produced so many masterpieces that they seem to be exhausted.

Albéric Magnard.

CCX.

Only a revolution like the invasion of the barbarians in the Roman Empire could vivify every æsthetic passion by destroying works and traditions.

Ibid.

CCXI.

It is in the arts themselves, as they exist,

that we must find the elements to rejuvenate them.

Albéric Magnard.

CCXII.

The characteristic of young schools is apparently an effort toward complex forms, expressing sensations and ideas of different æsthetic order.

Ibid.

CCXIII.

Most reformers in art are lacking in general ideas. They ask of isolated arts and not of associated arts a synthetic significance.

Ibid.

CCXIV.

Nowadays musicians exhaust themselves in literary effects, poets in effects of color or music.

Ibid.

CCXV.

Music is an abstract art,. formulating only very general ideas and sentiments, like swift-

ness, slowness, calmness, pain, joy, and suffering.

Albéric Magnard.

CCXVI.

Do not confound art with the sensations and the thoughts that give it birth.

Ibid.

CCXVII.

The plastic effects of music are puerile.

Ibid.

CCXVIII.

There is no dramatic expression in music.

Ibid.

CCXIX.

Synthesis of the arts is impracticable under a strictly musical form.

Ibid.

CCXX.

Painting is a concrete plastic art, subject to imitation of visible nature or to elements borrowed from nature.

Ibid.

CCXXI.

Synthesis of the arts is impossible under forms purely plastic, musical, or literary; but it is logical in complex forms resulting from an association of music, plastic art, and literature.

Albéric Magnard.

CCXXII.

To make symphonic poems intelligible, there should be in the orchestra a personage placed there for the special purpose of indicating at every moment the intentions of the musician.

Ibid.

CCXXIII.

The symphonic poem cannot escape the following dilemma: it is dramatic music and its programme is insufficient, or it is pure music and its programme is useless.

Ibid.

CCXXIV.

The lyrical drama is to-day the most complete form of synthetic art and the only one

which permits the fusion of words, sounds, and colors.

Albéric Magnard.

CCXXV.

Something stupefying and grotesque. Nowadays all women are alike, the good, the bad, the sublime, the mediocre, and the worse. They are painted, dyed, dressed, tattooed, and colored by the same ignoble artifices, and as one always gets the love that one deserves, they all have the same loves, the loves that may be inspired by rouge, blue pencil, and pomade.

Théodore de Banville.

CCXXVI.

Whether one be an idealist or a realist, whether one prefer antiquity or the middle age, none may refuse to recognize works of art in a Greek temple and in a Gothic cathedral.

C. Bayet.

CCXXVII.

To compose is to coördinate the elements of a work and, in general, adapt it to the needs

which it must satisfy and to the ideas and sentiments which it must translate.

C. Bayet.

CCXXVIII.

The execution of a work of art depends on the education which the artist has received and on the natural qualities which he possesses.

Ibid.

CCXXIX.

Style may be at one time the ethnic, chronologic, and personal characteristic of a work of art.

Ibid.

CCXXX.

Works of art, like all human phenomena, are too complex for the application of the rigorous processes of chemical analysis.

Ibid.

CCXXXI.

The history of art presents a continuous series of actions and of reactions.

Ibid.

CCXXXII.

A man does not understand art until he has reached middle age.

Alfred Stevens.

CCXXXIII.

Success belongs oftenest to mediocrity.

Ibid.

CCXXXIV.

There are no prodigies in the art of painting.

Ibid.

CCXXXV.

Learn to draw with your brush.

Ibid.

CCXXXVI.

Colorists love music.

Ibid.

CCXXXVII.

Be a man of your time, subject to your environment.

Ibid.

CCXXXVIII.

Fine colors are indispensable to fine pictures.
Alfred Stevens.

CCXXXIX.

One may not judge of the greatness of a work by its dimensions.
Ibid.

CCXL.

You cannot judge of the value of a girl by her height.
David de La Gamme.

CCXLI.

Do not confound great workers with ordinary plodders.
Alfred Stevens.

CCXLII.

Painters who think they are gods in art display weakness.
Ibid.

CCXLIII.

Give a nail's breadth of yourself rather than an arm's length of somebody else.

Alfred Stevens.

CCXLIV.

All in painting is contrast, color as well as drawing.

Ibid.

CCXLV.

To be a great painter you must be a great workman.

Ibid.

CCXLVI.

A subject is not necessary to a painting.

Ibid.

CCXLVII.

Pictures should not need literary descriptions.

Ibid.

CCXLVIII.

The style of the painter is execution.
Alfred Stevens.

CCXLIX.

There are offensive talents which appear to be saying perpetually, " Behold us."
Ibid.

CCL.

You pardon the faults of the Dutch masters because they apparently say, " I have done my best. I wish that I could have done better."
Ibid.

CCLI.

To the painter of nature nothing but the true is permitted.
Ibid.

CCLII.

Formulate æsthetically, do not imitate servilely.
Ibid.

CCLIII.

However mediocre he may be, the painter who reproduces the era in which he lives will be more interesting in time than the one who tries to reproduce an epoch which he has not seen.

Alfred Stevens.

CCLIV.

If your picture is that of a blonde and the buyer's wife is a brunette, your picture will run the risk of staying for a long time in your studio.

Ibid.

CCLV.

It is more difficult to paint maturity than childhood or old age.

Ibid.

CCLVI.

Samothrace's " Victory," which is in the Louvre, headless and armless, is as heroic as the bas-relief by Rude on the Arc de Triomphe.

Ibid.

CCLVII.

Admiration inspired by insincere artists will not last.

Alfred Stevens.

CCLVIII.

Paint what you see, what has just affected you; do not live on memories.

Ibid.

CCLIX.

The more elevated one is in art, the less one is understood.

Ibid.

CCLX.

The more distinguished the subject the harder it is to paint.

Ibid.

CCLXI.

The soul of the painter gives its imprint to all his work.

Ibid.

CCLXII.

Time is an infallible classifier.

Alfred Stevens.

CCLXIII.

Paintings of cows and sheep have always brought higher prices than pictures of horses.

Ibid.

CCLXIV.

One may not be just about a picture until ten years after its execution.

Ibid.

CCLXV.

Nothing is so difficult as easel painting.

Ibid.

CCLXVI.

The work of the painter is constant.

Ibid.

CCLXVII.

Painters of their own time are historians.

Ibid.

CCLXVIII.

Atmosphere in an interior is more difficult to paint than open air.

Alfred Stevens.

CCLXIX.

Old masters painted their own epoch.

Ibid.

CCLXX.

The more one knows the simpler one is.

Ibid.

CCLXXI.

The painter who obtains approval of only women is lost.

Ibid.

CCLXXII.

You may judge of the sentiment of an artist by a flower which he has painted.

Ibid.

CCLXXIII.

The one who does not know **how to** paint a lemon on **a** Japanese plate is not a delicate colorist.

Alfred Stevens.

CCLXXIV.

There **is** as **much** expression in **a man**'s hand as in **his** face.

Ibid.

CCLXXV

Painters who do not use **nature weary** the public.

Ibid.

CCLXXVI.

It is an art **in** painting to know when to stop.

Ibid.

CCLXXVII.

Ignorant **men** always display **a great** deal of knowledge.

Ibid.

CCLXXVIII.

If you have unexpectedly done well attribute your success to the effect of previous study.

Alfred Stevens.

CCLXXIX.

Let the sitter for a portrait take an habitual pose and do not strive for effect by making him take an unusual one.

Ibid.

CCLXXX.

The tendency of art critics is to be preoccupied more by the literary than the technical elements of pictures.

Ibid.

CCLXXXI.

The public likes pictures in which hard work is visible.

Ibid.

CCLXXXII.

The public likes to get its money's worth.

Ibid.

CCLXXXIII.

In painting be a painter first, a thinker after-
ward.

Alfred Stevens.

CCLXXXIV.

Every painter, however bad, has his public.

Ibid.

CCLXXXV.

Please yourself before thinking of pleasing
the public.

Ibid.

CCLXXXVI.

It is more difficult to paint smiles than tears.

Ibid.

CCLXXXVII.

It is more difficult to paint a young girl than
an old woman.

Ibid.

CCLXXXVIII.

Everything everywhere is beautiful.

Ibid.

CCLXXXIX.

It is preferable to paint a blonde because her hair will blend more harmoniously with the skin than the hair of a brunette.

Alfred Stevens.

CCXC.

A picture should not appear to stand out of its frame.

Ibid.

CCXCI.

Early masters made the sign of the cross before painting.

Ibid.

CCXCII.

The greatest difficulty in art is the nude.

Ibid.

CCXCIII.

It is easier to paint a woman than a man.

Ibid.

CCXCIV.

An old shoe is more picturesque than a fashionable man's dancing shoe.

Alfred Stevens.

CCXCV.

God's masterpiece is the human face.

Ibid.

CCXCVI.

A woman's glance is more attractive than a ray of sunlight.

Ibid.

CCXCVII.

In France, where fashion leads everything, even in the art of painting, there are fashionable tones.

Ibid.

CCXCVIII.

Art would not be art if it did not pass over the heads of the vulgar.

Ibid.

CCXCIX.

Artists whose value was disputed are not better appreciated now than they were before; but as their works have much value in money, followers flock after them.

Alfred Stevens.

CCC.

Adverse criticism of one who knows is more flattering than praise of one who is ignorant.

Ibid.

CCCI.

Violence is not vigor.

Ibid.

CCCII.

Time makes beautiful painting more beautiful and bad painting worse.

Ibid.

CCCIII.

Bad painting cracks in the form of the sun.

CCCIV.

Flies respect good painting.

Ibid.

CCCV.

Do not paint religious subjects if you have no faith.

Alfred Stevens.

CCCVI.

Great colorists, in general, were born on the seashore.

Ibid.

CCCVII.

At high noon the sun is an anti-colorist.

Ibid.

CCCVIII.

The moon beautifies everything.

Ibid.

CCCIX.

When people ceased to take interest in painting, historical subjects were invented.

Ibid.

CCCX.

Japanese art is a great element of modern art.

Alfred Stevens.

CCCXI.

All is love in Japanese art.

Ibid.

CCCXII.

The Japanese are real impressionists.

Ibid.

CCCXIII.

Paint a peasant and you are a thinker; paint a society woman and you are a fashionable painter. Why? A fashionable woman looks at the sky oftener than a peasant.

Ibid.

CCCXIV.

There is a moment when the painter should not allow himself to be dominated by nature.

Ibid.

CCCXV.

The invention of photography has **revolu-tionized art** as railroads have revolutionized industry.

Alfred Stevens.

CCCXVI.

Independent artists have audacity.

Ibid.

CCCXVII.

Do not make a model pose for the hands of **a** portrait. It is bad faith.

Ibid.

CCCXVIII.

You **are** not a modern artist because you paint modern costumes, but because you have modern sensations.

Ibid.

CCCXIX.

Masterpieces are simple.

Ibid.

CCCXX.

Great artists are good critics.

Alfred Stevens.

CCCXXI.

Portrait painting is perhaps the finest of all painting.

Ibid.

CCCXXII.

Painters, express yourselves in your work !

Ibid.

CCCXXIII.

Art is aristocratic.

Ibid.

CCCXXIV.

Draughtsmen are born, not made.

Ibid.

CCCXXV.

Art counts for nothing at popular exhibitions.

Ibid.

CCCXXVI.

A spark of light by a Dutch master is a stroke of intellect.

Alfred Stevens.

CCCXXVII.

It is easier to draw a violent than a simple movement.

Ibid.

CCCXXVIII.

Nothing is as useful as comparison.

Ibid.

CCCXXIX.

By the palette of a painter one may know what he is.

Ibid.

CCCXXX.

In our time talent runs about the streets, genius is rarer than ever.

Ibid.

CCCXXXI.

A badly built man was never a master in the plastic arts.

Alfred Stevens.

CCCXXXII.

A fine picture admired at a distance should bear close analysis.

Ibid.

CCCXXXIII.

There are pictures full of talent which should be hung in the anteroom.

Ibid.

CCCXXXIV.

Do not depict a winter subject in summer.

Ibid.

CCCXXXV.

Good pictures should be in good company.

Ibid.

CCCXXXVI.

One has to learn to see, as in music one has to learn to hear. Those who say, " I have never seen nature like this," often mean that they have not the intelligence of the artist.

Alfred Stevens.

CCCXXXVII.

Three or five would be a sufficient number of members for any jury.

Ibid.

CCCXXXVIII.

Study and interpret the masters, but do not try to imitate them.

Ibid.

CCCXXXIX.

Painters should sometimes consult sculptors.

Ibid.

CCCXL.

It is wrong for a painter to abandon the

country in which he was born and in which he passed his youth.

Alfred Stevens.

CCCXLI.

Studies **may** almost always be found superior to finished works.

Ibid.

CCCXLII.

Everything requires study.

Ibid.

CCCXLIII.

An artist should never lose **his** primitive simplicity.

Ibid.

CCCXLIV.

An artist never acquires suppleness until he fully possesses his art.

Ibid.

CCCXLV.

Painting is nature seen through the prism of an emotion.

Alfred Stevens.

CCCXLVI.

Do not let students draw from memory.

Ibid.

CCCXLVII.

Comfort is injurious to art.

Ibid.

CCCXLVIII.

A fine painting is agreeable to the touch.

Ibid.

CCCXLIX.

A true painter is a thinker.

Ibid.

CCCL.

Masters have not always produced masterpieces.

Alfred Stevens.

CCCLI.

Do not allow your brain to be dominated by the dexterity of your hand,

Ibid.

CCCLII.

The public confounds romance with poetry.

Ibid.

CCCLIII.

The public likes subjects in costumes.

Ibid.

CCCLIV.

Charcoal is a flatterer.

Ibid.

CCCLV.

Born painters never believe that they have succeeded.

Alfred Stevens.

CCCLVI.

Avoid beautifying models.

Ibid.

CCCLVII.

Reputations are easily acquired, but not easily made lasting.

Ibid.

CCCLVIII.

Old Europe will some day accept an artistic renaissance from young America.

Ibid.

CCCLIX.

If you live in Paris you cannot paint flesh like Rubens.

Ibid.

CCCLX.

Each country gives an individual charm to woman.

Alfred Stevens.

CCCLXI.

There is no grace without strength.

Ibid.

CCCLXII.

The time will come when Germans will be prouder of Albert Dürer than of the great Frederick.

Ibid.

CCCLXIII.

A painter is rarer than a man of learning.

Ibid

CCCLXIV.

Men of elevated taste are rarer than men of talent.

Ibid.

CCCLXV.

Teachers should discover and develop apti-
t des of students.

Alfred Stevens.

CCCLXVI.

Do not encourage too much the art of paint-
ing; rather discourage it.

Ibid.

CCCLXVII.

It is a crime to retouch a master's painting.

Ibid.

CCCLXVIII.

A book or music may provoke tears; never
a picture or a piece of statuary.

Ibid.

CCCLXIX.

Painting is not made for exhibitions.

Ibid.

CCCLXX.

Painting is not a way to wealth
Alfred Stevens.

CCCLXXI.

It is difficult to preserve a great reputation when one's works are not numerous.
Ibid.

CCCLXXII.

To live many years and to preserve always celebrity as an artist in painting seems to me to be almost an impossibility.
Ibid.

CCCLXXIII.

Lament a painter who lives too long for his art.
Ibid.

CCCLXXIV.

Do not paint continually in your studio.
Ibid.

CCCLXXV.

Fine painting ought to withstand the magnifying glass.

Alfred Stevens.

CCCLXXVI.

Painters should know chemistry.

Ibid.

CCCLXXVII.

What a disquieting and capricious thing is painting.

Ibid.

CCCLXXVIII.

In our day sculpture is perhaps superior to painting.

Ibid.

CCCLXXIX.

Art is jealous and will not forgive a moment of forgetfulness.

Ibid.

CCCLXXX.

Serve art or letters.

Alfred Stevens.

CCCLXXXI.

POSING FOR HANDS.

One may not see hearts. If one could, Mrs. —— would seem more strange than if she walked in Broadway among the cable cars in clothes of the fifteenth century. Twenty-four years of age, young, beautiful, charming, rich, honored, a widow, her blue eyes fringed with long eyelashes and her hair unimproved by any artifice, she is not a member of fashionable society and she never goes to teas. Although joyful, and not pedantic, she is a fanatic in art and stays at home to play beautiful music or to read Shakespeare. By virtue of an order of ideas which has been abolished, love is in her view inseparable from admiration, and she has all the traits of Lucrezia Floriani except the latter's inability to fall in love. So, she is an anachronism in flesh and bones, but in bones so well proportioned and in flesh so beautiful that

one is forced to forgive her lack of realistic exactitude.

She saw so many paintings by Case at the club exhibitions that she fell in love, not only with his paintings, but with the artist himself. In his grand historic figures she admired not only the tragic scenes, the beauties of composition, the personages evoked with rare power; in his portraits, she saw not only the noble intimacy of the faces, the sincerity of the attitudes, and the power of intuition with which the artist had interpreted feminine grace; but she particularly admired the adorable colors, the shivering blues and the singing symphonies.

While she relished the spectacle which these flowers of light created, she felt that she was the friend of the artist who had made them bloom under his magic fingers. She wished to say to him that she was his friend, and she wrote him a letter bravely signed with her real name. But she received no answer to this letter, nor to the others which followed it; and as she was not a woman that circumstances could tame, she put on a gown which would have dazzled the gods and went to Washington

Square. She stopped her carriage near the arch and walked quickly to the hall wherein the painter produces his great Oriental massacres.

She was received at the door by the young model, Furness, who perhaps owes his name to his hair, redder than blazing coals.

"Madam," he said quickly, "come in. The master is waiting for you. What name shall I say?"

Without stopping to observe how contradictory the two periods of his phrase perhaps were, Mrs. —— followed her guide. But it is necessary to say what tempest agitated the vast studio and in what frame of mind Mrs. —— was to find the painter.

The day before he had almost finished the portrait of Mrs. Elliott, whose beauty has always moved New York. The portrait lacked only the hands, that is, everything; and the lady could not pose for the hands because she had to give a dinner and call on her tailor. The painter had obtained the promise of a sitting from Laura Antoni, the only model who can give to a painter hands of a patrician that are at all presentable. He expected her at

8 A. M. At 8:30 he had already reached the last extreme of impatience. A messenger arrived with a letter from Laura, who had taken the precaution to write her name in large letters on the envelope. The painter handed the letter to Furness and said, " Read quickly and tell me in two words what it means. Is Antoni ill?"

" No, she is well, but she does not want to come here," Furness said. " She thinks that Washington Square is not fashionable enough. Hereafter she will pose only in the vicinity of Fifty-seventh Street. She is one of the sort of people who want to be emperors of the Occident."

" One thousand million brushes!" exclaimed the painter. " The hands, the portrait, my $5,000, my time! It does not matter. Let us work."

He furiously painted on a tall canvas cuirasses of bronze and blood-red cloaks. Then he stuffed his pipe, lit it, took two or three puffs, placed it on the piano, sat and drew from the instrument a tempest of sounds which struck with terror the solemn silence. Furness, pale

with fright, sat on the floor and copied a plaster cast.

"Listen," said the painter. "Although it is impossible, if the gods wish it may happen that a woman may come whose hands may be like those of Mrs. Elliott."

"Certainly," said Furness, "it is quite impossible . . . and even probable. At all events I shall admit every woman of distinction . . . without distinction."

The bell rang, he went to the door, came back and announced Mrs. ——. With unconcealed curiosity she looked at the painter, anxious to know if he resembled his work. She admired his clear eyes, his firm mouth, his honest and brave air. At once she knew that she was subdued; and it was lucky that she knew, although she was not easily astonished, because if she had not known she would have been shocked by the manner of the painter, who looked at her for a moment in silence and said in a voice which sounded to her like delicious music, "Take off your gloves!"

She took off her gloves. He admired her hands, long, fine, pure, transparent, with nails

which were as pink as pinks. He said nothing, but he seemed to be, and he was in fact, in an ecstasy of joy. He offered a chair to her, placed a cushion under her feet, and arranged her hands with infinite care in the pose that he required. Then he went before his easel and began to paint with an inspiration full of certainty. Gifted with the best quality of feminine instinct, and understanding that she **was** not to understand, she kept silent for an hour. At last she saw that the painter was less arduous at his work, and looking at him with her eyes, which were full of sparks of gold, she asked, " May I talk ? "

" You may if you wish," he said, " for your voice is celestial. If I were you, however, I would not talk What words could you utter which would be worth the accents of your eyes and of your lips? When nature makes masterpieces like these, she dispenses them from explaining themselves. They are like good drawings which do not require titles."

" Did you read my letters ? " she asked.

" Your letters ? We shall talk of this later," he said, " in five minutes."

He painted quickly and in five minutes said to her, " Now rest a little, if you wish." She stood before the canvas and exclaimed, " This woman will be immortal, but I see that you have given my hands to Mrs. Elliott."

" Yes, madam," the painter replied. " We were more generous than heaven, for the hands that we have given are handsomer than Mrs. Elliott's hands. Is it not intensely agreeable to be like the sun, which gilds and transfigures objects that have no interest ? "

" But my letters ? " she asked.

He opened a desk covered with inlayings of shell and mother of pearl and handed to her a package of letters.

" What ! You have not read them ! " she exclaimed.

" No, madam, I never read a letter, for if I read letters I might wish to write some. Afterward I might wish to rewrite the Iliad. I shall open my heart to you, not as to a sister, for one never says anything to one's sister, but as to a creature chosen among all others. I wish to paint not the ancient conventionalities

of schools, but history as Shakespeare saw it. I am a stone-breaker on the highway. I do not sleep, I do not eat, I have no amusement of any sort. Do you think that I can find time for literature?"

"But," she murmured, "will you never know what love is?"

"Certainly not," he said in anger, "I shall never know; for painting is an art, love is another, and one of the two is enough to fill a man's life. Suppose for an instant I should be loved by a woman such as you! To build a nest worthy of her, to clothe her with stuffs created for her, to adore her, amuse her, kiss her hands, fall in ecstasy, be jealous, admire masterpieces in her company, lead her into forests of flowers—would these things not be enough to occupy every second of my life? But your hands are not yet finished; let us work a little more, if you please."

"I am willing," said Mrs. ——, who sat while the painter took his brushes; "but speak to me."

"I have known, madam, all the illusions

that have an influence over artists," said the painter. " I have had success, honors, great orders; but I am a very poor pupil. You asked if I were never to know love. I know Painting. She never yields. She escapes like Galatea, not under the willows, but I know not where My colors are enthusiastically admired, but I look at a corner of the sky, at living flesh, at a piece of stuff, and I find that my colors are dirty. You may rest now. I have finished."

" These hands are a pure masterpiece," said Mrs. ———; " they live, they breathe, they were made with light. What master ever did better ? "

" To-day, madam," he said, " I worked under exceptional conditions. Even the gods of art may not have models like you."

" Meanwhile," she said with an arch expression, " you owe me for my sitting."

" It is true," he said. " It is too late for more work, and as my cook, who resembles Michael Angelo's Sybils, says, ' You shall be entirely satisfied.' "

David de La Gamme.

CCCLXXXII.

To scrape Notre Dame de Paris is a crime, but it is well to cleanse Notre Dame de Lorette.

Alfred Stevens.

CCCLXXXIII.

Many painters stop where obstacles begin.

Ibid.

CCCLXXXIV.

The painter should economize all the heat of his temperament until the last stroke of his brush.

Ibid.

CCCLXXXV.

Paint nobody's portrait for nothing. The person who sits for it will never defend it from adverse criticism.

Ibid.

CCCLXXXVI.

Virtuosity should not be confounded with trickery.

Alfred Stevens.

CCCLXXXVII.

The Dutch and Flemish painters are the greatest in the world.

Ibid.

CCCLXXXVIII.

Great painters, more than great writers, great musicians, or great sculptors, are qualified to understand the other arts.

Ibid.

CCCLXXXIX.

Some painters useful to others are of no use to themselves.

Ibid.

CCCXC.

A painting which produces an illusion of reality is an artistic lie.

Ibid.

CCCXCI.

Each country should have its pictorial mark.
Alfred Stevens.

CCCXCII.

At a cattle show the public prefers the five-footed ox.
Ibid.

CCCXCIII.

English art is a free art and by reason of its liberty infinitely varied, full of surprises and of unexpected initiative.
Ernest Chesneau.

CCCXCIV.

The only great art of painting of the English school is portrait painting.
Ibid.

CCCXCV.

The only rule of great artists is as follows: Judge the past and forget it.
Ibid.

CCCXCVI.

The most necessary quality of the ambitious in art is patience.

Alfred Stevens.

. CCCXCVII.

You shall be mistaken in art if you look only at your own mind.

Ibid.

CCCXCVIII.

To know is the only basis of infallibility in art.

Ibid.

CCCXCIX.

One may comprehend of the art of the Middle Age the exterior decoration, but not the spirit.

Ibid.

CCCC.

Picturesque processes must be different from literary processes,

Ibid.

CCCCI.

Under no literary form, plastic or pictur-esque, in any art, is the characteristic of a race expressed in traits as legible as in caricature.

Alfred Stevens.

CCCCII.

The ideal of caricature is positive direct precise, and very special. It is an ideal of truth.

Ibid.

CCCCIII.

Hatred of vice and love of innocence are only different manifestations of the same senti-ment.

Ibid.

CCCCIV.

The art of a nation has its root in the na-tional character itself.

H. Taine.

CCCCV.

Even as each geologic revolution carries with it its fauna and flora, each great transformation of society carries with it its ideal figures.

H. Taine.

CCCCVI.

Art cannot flourish until after a long succession of trials, of researches, of transformations, and of progress.

A. J. Wauters.

CCCCVII.

Simple truth, sincerity, good faith, are the characteristics of eternal works.

Ibid.

CCCCVIII.

Nothing is so odd as the mixture of Italian culture and persistent Germanism, of foreign language and indelible local accent, which characterizes the mixed school of Italo-Flemish artists.

Eugène Fromentin.

CCCCIX.

Even in painting, genealogy may be the only means of estimating the utility of those who try to understand the greatness of those who discover.

Eugène Fromentin.

CCCCX.

Great artistic families are one of the most curious characteristics of the Flemish school. An individual takes a brush or a graver and at once art turns the head of all the people who surround him.

Ibid.

CCCCXI.

Painting is the language of Belgium

Ibid.

CCCCXII.

Talent alone makes art. It makes art with everything that is offered. There is no trade which a great artist may not elevate.

Ibid.

CCCCXIII.

Is an artist ever perfect? Nobody ever is.

Eugène Fromentin.

CCCCXIV.

Van Dyck learned from the Venetian school how to raise a physiognomy to the height of a type by accentuating its character and its dominating traits.

Ibid.

CCCCXV.

No school, not excepting the Dutch school, has interpreted animal life with the superiority of the Flemish school.

Ibid.

CCCCXVI.

It is one of the glories of the great school of the North to have understood that it is possible to make art with prairies, woods, rocks, clouds; to have, in a word, created the landscape.

Ibid.

CCCCXVII.

Flowers have been, from the first periods of painting, objects of minute study to Flemish artists.

Eugène Fromentin.

CCCCXVIII.

The moment an artist thinks of money, he loses the sentiment of the beautiful.

Denis Diderot.

CCCCXIX.

The academies of Antwerp and of Bruges were founded only to preside over the funeral ceremonies of the Flemish school.

A. J. Wauters.

CCCCXX.

The word realism was invented to indicate a return to the ancient traditions of the schools of Velasquez, Franz Hals, and the little Dutch masters.

Ibid.

CCCCXXI.

Painting is, in Belgium, the nation's poetical language.

A. J. Wauters.

CCCCXXII.

The artistic production of a great nation is a result of the aptitudes of the people and of its character.

Henry Havard.

CCCCXXIII.

There is in the life of every people a blessed epoch where all become resplendent at once.

Ibid.

CCCCXXIV.

The expression of the sentiments of a nation are marked with its imprint.

Ibid.

CCCCXXV.

Art is a nation, a people.

Ibid.

CCCCXXVI.

The art of a nation is the synthesis of its dominating thoughts.

Henry Havard.

CCCCXXVII.

An artist must compel nature to pass through his intelligence and his heart.

Paul Delaroche.

CCCCXXVIII.

Reasoning will never have on an artist the influence of a spectacle.

Henry Havard.

CCCCXXIX.

Whenever color is the principal preoccupation of an artist, his art tends naturally to be materialized.

Lamennais.

CCCCXXX.

It never occurred to a Dutch artist that a work of art might have a philosophical impor-tance.

Henry Havard.

CCCCXXXI.

There is a sort of Rubicon which art should not cross.

Ibid.

CCCCXXXII.

Artists, despite the greatest faults, may by the perfection of certain qualities charm the most prejudiced minds.

Ibid.

CCCCXXXIII.

In all the branches of art the danger is to imitate mechanically masters who are given as models and who are themselves heavy, false, and conventional.

Ibid.

CCCCXXXIV.

Cease to observe nature and your sentiment of color will diminish in intensity.

Henry Havard.

CCCCXXXV.

A man does not allow himself to be reproduced easily with lines only.

G. Maspéro.

CCCCXXXVI.

Excessive polish has not spoiled Egyptian statues, it has not spoiled them more than the works of the Italian sculptors of the Renaissance.

Ibid.

CCCCXXXVII.

Social hierarchy followed the Egyptian in the tomb and regulated his pose after, as it had regulated it before, death.

Ibid.

CCCCXXXVIII.

When civil wars and foreign invasions placed Egypt at a step from its ruin, art suffered like the rest.

G. Maspéro.

CCCCXXXIX.

In Egypt taste for the beautiful and love of luxury had soon penetrated into all classes of society.

Ibid.

CCCCXL.

In Egypt art and trade were not incompatible.

Ibid.

CCCCXLI.

In Egypt even the caldron-maker tried to give to his humblest works an elegant form and tasteful ornamentation.

Ibid.

CCCCXLII.

Æsthetic pleasure is like sympathy, which is not always provoked by resemblances, but often by differences. It is not true that a people seeks in works of art only its own image. At certain moments one seeks for one's contrary; one feels the necessity for antithesis. That is why Gretchen loves Carmen.

Jean Breton.

CCCCXLIII.

A great artist is often too much disposed to see everything under the ideal form of beauty. For him even evil has its æsthetic seductions. The cruelty of things and of men are transformed under his pen in dramas which make one tremble, but which enchant one.

G. Hérelle.

CCCCXLIV.

Sword-thrusts are like pictures. One must not look at them when they are new.

Leon de Tinseau.

CCCCXLV.

That a painter has the soul of a poet is, in the view of certain people, useless and almost a defect.

Jean Lahor

CCCCXLVI.

Poets were the great primitive painters, the sublime painters of Christian ecstasy; poets were the quatrocentists; poets were all the masters '

Ibid.

CCCCXLVII.

What painter is not bound to add his fantasy, his dream, his thought, his soul, to his vision of nature, since art is but nature transfigured, transposed by fantasy, dreams, thought, soul of an artist?

Ibid.

CCCCXLVIII.

Superior art, like Greek art, for example, is

nature arrived in some minds at superior development.

Jean Lahor

CCCCXLIX.

Most of the Pre-Raphaelites were astonishing painters of minds.

Ibid.

CCCCL.

Art in England is constantly preoccupied by the obscure extra-terrestrial.

Ibid.

CCCCLI.

The extra-terrestrial is the horizon of life and of the mind.

Ibid.

CCCCLII.

Beauty is form of visions made noble.

Ibid.

CCCCLIII.

The mind of every one of us is apparently made of minds of diverse ages, or of diverse

countries, which live together as well as they can.

<p style="text-align: right;">*Jean Lahor*</p>

CCCCLIV.

I feel that there are two men in me.

<p style="text-align: right;">*Ibid.*</p>

CCCCLV.

Pessimistic doctrine, which is mine and that of many minds, makes imperious necessity for the beautiful, which consoles one for the misery and the ugliness of things.

<p style="text-align: right;">*Ibid.*</p>

CCCCLVI.

It is well that artists and men of science incessantly bring together the bonds of sympathy between nations that politicians are incessantly trying to separate.

<p style="text-align: right;">*Ibid.*</p>

CCCCLVII.

Art is neither ancient nor modern, but perpetual.

<p style="text-align: right;">*Ernest Hoschedé.*</p>

CCCCLVIII.

Painting which is ancient and classic, or classic and ancient, is black and yellowed. Young men who have not, and will never have, any talent say to themselves, " The masters paint black and yellowed, let us paint black and yellowed."

Ernest Hoschedé.

CCCCLIX.

Paintings by Rubens which have been washed have appeared fresh, fleshy, blond, and dazzling.

Ibid.

CCCCLX.

The young girl of the Egyptian museum, who is a contemporary of Cleopatra, has preserved the red tones of her lips and the pink tones of her gown.

Ibid.

CCCCLXI.

Mantegna has remained aerial and pure in color.

Ibid.

CCCCLXII.

DIGRESSION. BY PAUL VERLAINE.

You have expressed the desire to read in letters a short relation of my journey in Holland.

Here it is in a few pages that I will fill as well as possible Having been invited by a group of artists and men of letters to give in their country a series of lectures, I willingly acceded, having always been curious to know that country which the ungrateful Voltaire, its host, denounced as full of " canals, canards, and canaille," that country which, I proclaim it in my turn, is evidently full of canals and of canards, but is fuller of hereditary talent and of traditional, preserved history.

November 2, 1892, All Souls' Day, a good augury, I quitted the Northern station in— thanks to miraculous funds which came from the Low Countries—a special wagon, a first-class wagon, if not like a sovereign, at least like a presentable prince. There were mirrors in the panels and mahogany planks which could be lifted up at the right moment for breakfast or dinner.

It is useless, is it not? to describe to you the sad landscape of the surroundings of Parıs, St. Denis excepted, with its monkish, formerly royal abbey, always divine, and its islands placidly pretty in summer, but infinitely melancholy in the declining autumn. Then manufactures of I know not what, huts, cabins, ruins, the use of which is unknown to me. A little peasant serenity follows after twenty minutes of mediocre rapidity. Real plowed lands, authentic trees defiled in turn to give place, after an hour, to the Creil station surrounded by factories of a new style, in the midst of a tolerable country.

Then the train rolls until it reaches Saint Quentin. The successive landscapes that the mist of the season softens pass indifferent as in a dream, neither good nor bad, while the telegraphic wires go up and down, and their posts look like thin and very tall Capuchin monks. And the white plume of the locomotive, the only plume—but so beautiful!—of our civilization, displays itself, graceful and coquettish, on and through the sights traversed.

Varied, if one think ıs, the course of travel

from Creil to Saint Quentin; a space of coun-
try uniform but not disagreeable, if not to the
eye at least to the intellectual eye. It talks,
this space, almost always cultivated, and, at
this hour, consisting of long furrows awaiting
the exit of winter to become green and the exit
of spring to be turned into straw and sheafs.
Little by little the earth blackens, the rare
trees become thinner and look like lame skele-
tons. Factories smoke, and here is a brick!—
the brick of the North, the blood-red brick,
erected into vast constructions destined to in-
dustry. In the distance are tall chimneys, dark
and sinister.

"Saint Quentin! Twenty minutes!"

This is uttered by an officer dressed in short
dark-green waistcoat of the sort which the Eng-
lish call corduroy, and wearing a flat cap of black
polished leather with a visor copper lined.
Oh, the accent! I read recently in an article,
very well written by a poet of Lille, that the
accent of the Picards was dull, deaf, so to
speak. Deaf? Yes—what serious patois is
not deaf? It must correspond to the literally
crushing labor of the fields. But dull? Oh, no!

But you have not asked me for a lecture,
you have asked for a relation of my journey.
I begin again. Go on, roll!

The train advances slowly, heavily, through
suburbs wherein the huts are low and white-
washed, and crowds of children appear to see
the train pass. Nothing remarkable happens
until we have reached the Belgian frontier,
where the telegraphic posts are no more long
poles, but inclined cones. They look now like
legs of giants who are drunk and are falling
down. These companions will accompany me
to The Hague and later to Leyden and Amster-
dam.

CCCCLXIII.

I forget the name of the station where the
Belgian custom-house conducts its operations.
Twenty minutes to visit the luggage. Travel-
ers who carry only bag—this is my case—do
not need to get out of the wagons. An old
custom-house clerk, clean shaven, in a dark
uniform, asks :

" Have you anything that is new ? "

" ? "

After my belated reply, negative, or rather confirmative, the worthy man writes with a piece of chalk one of those cabalistic signs which signify in this style of stenography, " visited " or " let pass " or something like this, evidently. Oh, esoteric manners; oh, administration—international!

And I take advantage of the time which remains to me to order a portative breakfast. Like all the others is the buffet, with the single original note that it contains a bust of King Leopold II., placed in an elevated position, a long horsey head, sad and distinguished, coming out of the collar of a tunic embroidered with gold, between the epaulets of a general of division, in something which is chocolate as much as it is earth, earth which is really too much cotta.

In the various spoken transactions to which I have to devote myself in view of the order and of the payment for the aforesaid portative breakfast, I find again, after seventeen years of former acquaintance, the Belgian language at which the Parisians make too much fun.

Philologists, explain to us whence come, for

example, these odd ellipses, " Comest thou with ;" these expletives, " For one time, knowest thou ? " I do not laugh at these locutions, for in my eyes Belgian is only a local French, with gently naive turns of expression.

Here I am again digressing. Pshaw ! You excuse me, do you not ? After all, if a familiar relation in simple letters is to be a lecture, even if you swore at me I would digress whenever the occasion seemed to me to be logical or simply presented itself. Digression, after all, is a flower in a buttonhole, a ring on a finger— also, and perhaps oftener, a flag, or rather a pavilion covering merchandise.

Here I am in my special wagon—in railway talk it is called a toilet wagon—a charming word, is it not ? It sounds Belgian. The buffet waiter brings to me in a wicker basket, red, oblong, shut with an open padlock, my breakfast, hence portative, you see.

I lift the mahogany plank which is opposite me, place it on two supports which I find in the lower panel, and I place on this pocket table—if it may be so called—two dishes containing meat, two dishes containing vegetables,

a cake, a half bottle of Macon and a quart bottle of champagne. The whole thing for ninety cents. I forget the name of the caterer.

Finished my breakfast, let us look at Belgium. I know for having walked through them —how many times I do not know—these poor solitudes of the Hainaut. Some villages, titles and plaster. The train goes through sights more and more black. After an hour, Mons!

Mons! A city where I have lived for a long time and which I do not know. Yes, in my early childhood I slept one night at the hotel. When I was much less young I stayed there for more than a day and more than a night, not at the hotel, and, as I was not ill, consequently not at the hospital, either. And yet I do not know Mons. Fix this up as well as you can!

It is, therefore, the first time that I seriously see the capital of this province. It seems to me to be rather red, with a very high tower, much ornamented, in bluish stone.

The conductor of the French train had quitted us in his dull uniform, black with attributes, collar, bands, violet braid. In his place a pretty young man, blonde, tightened in a black

tunic with dazzling flat copper buttons, wearing a rigid cap with a copper-lined visor, presides over our destinies. Charming, the young man who replies to my confidences relative to my anxiety about crossing the Belgian frontier toward Holland, a land where French does not flourish.

"Do not fear, sir; I will recommend you to the director of the Holland train.

Confident in this assurance, I reinstalled myself in my solitary wagon—and so much the better. I have a bird's-eye view of Brussels— this city wherein I have in my time terribly, although for only a few months, but what months! lived. Well, Brussels is very gentle.

Tiles and plaster for the suburbs, Spanish fragments and Gothic lost in new things—several ancient marvelous things, the City Hall with its immensely high belfry, surmounted by St. Michael brandishing in the form of a sword a sheaf of lightning-rods—it's the fashion for lightning-rods in Belgium to be grouped in the form of swords brandished in sheafs. Opposite the City Hall, on the so pretty place, the admirable Royal House—do not confound with the royal palace, an ugly building. They did well

to take from in front of this marvel of art, which it masked, the bronze group of Egmont and of Horn. Saint-Gudule, pure Gothic, a little heavy doubtless, but imposing because it is heavy. . . . As for modern buildings, permit me not to dwell upon them. They are useful doubtless, but thick, and without any art. Yes, Brussels is an amiable city, even when seen in this cursive fashion, and I can understand that the poet of the Wandering Jew made his hero stop here to talk with very docile bourgeois.

We defiled toward Antwerp, an agricultural country with immense plains that belonged to cows and to sheep, studded with clear villages and elegant castles a little out of shape, but very amusing all the same. Then the scene changes and it is Campine : severity in quasisterility. The train takes us into the states of her young Majesty, Queen Wilhelmina, first of the name.

CCCCLXIV.

Every subject that the painter chooses imposes obligations upon him.

Georges Lafenestre.

CCCCLXV.

The first of the obligations of a painter is to present his subject logically and to express with judgment his idea of it.

Georges Lafenestre.

CCCCLXVI.

A painter must give seriously, sincerely, and completely, even in a sketch or in a study, all that he has seen, felt, and desired about a subject.

Ibid.

CCCCLXVII.

Many painters make use to-day of democratic realism and will fall to-morrow into weak mysticism.

Ibid.

CCCCLXVIII.

You cannot expect of painters convictions more settled than those of statesmen and philosophers.

Ibid.

CCCCLXIX.

If a painter has the sincerity of the moment, do not ask more.

Georges Lafenestre.

CCCCLXX.

There will always be Christians and pagans, materialists and mystics, learned and ignorant people, and each of these classes will always demand art works in accordance with their tastes.

Ibid.

CCCCLXXI.

A DIGRESSION. BY PAUL VERLAINE.

Nothing resembles the Belgian frontier more than the confines of Holland. Some green, a few trees, water and brooks, very humble villages near to one another. As you advance the green becomes greener, the trees become rarer, the water becomes less modest. It falls into thin canals for the love of God, very long, separating in parallel bands narrow prairies

where the cattle is abundant. Among them, a
windmill.

The gentle monotony of these aspects, which
are infinitely regular, wearies a little one's first
curiosity. So profound was this sensation in
me that I fell asleep in a corner of the wagon.
It was a half sleep, full of vague preparation
for my lectures, so full of them, in fact, that it
degenerated into a serious and prolonged sleep,
until the twilight lit the lamp on the ceiling of
my wagon. I regretted that I had been pre-
vented for a long hour from seeing sites which
were so new to me and which must have varied
during my half-death. They had varied, the
sites !

An immense extent of golden water, made
green at the horizon by the last efforts of the
setting sun, displayed itself motionless, with
black veils of boats hardly moving in the grow-
ing obscurity. This at the left. At the right,
the same spectacle. An interminable bridge
of cast iron on which the train passes slowly,
with a regular noise, powerful, almost terrible,
so precisely regular it is in its power. When
the night came, the vision of water had effaced

itself, to give place to villages which one would think submerged, so surrounded by water they are. A steeple, windmills, shadows of houses, dotted with vacillating lights—this is Dordrecht.

The darkness, lassitude, made me return to my corner, charmed by a severe charm, yet very soft. Expectation, you know, expectation of something good, cordial, besides curiosity, somnolent feeling, took hold of me, not to quit me again until the same noise, powerful and regular, led us into rows of lights.

A new cast-iron bridge passing over houses extravagantly pointed, on canals, on streets all gas and electricity, revealing large stores, commerce, and an elegance almost Parisian. A large city . . . Rotterdam.

The train starts again in the night after a sharp halt at the Rotterdam station. It must —it is night—traverse water, rivulets, water of larger dimensions, with black boats carrying red lights that swing in the dark, and there are perspectives of windmills forming tall black crosses under the black and red sky.

After an hour of this travel the locomotive

whistles for a long time—and we enter The Hague station.

I ask myself where I am, and in my extreme trouble at hearing the yellers yell " Den Hagg!" think that the English call Londres, London!

Well, while I am hesitating and feeling bored, an excellent friend who had known me in Paris makes a sign to me from the platform, and at his gesture came from the shadow into full electricity ten, twenty persons who distribute among themselves my light luggage and carry rather than lead me to a comfortable carriage, such as Paris has not, and then I am led by a trotting horse, an excellent horse—do all the things that these Hollanders have appear excellent?—followed by two carriages, through pretty streets not too much, not enough perhaps, Flemish: well lighted and most elegant We pass often under passages ending into ducal and royal squares, each one of which possesses a William the Silent in stone, in marble, or in bronze. There is even one by the Mathildian Nieuwerkerke.

We pass by a cortège of little pink girls

in sabots coming out of church. Black blouses, white aprons; you would think yourself looking at provincial Catholic orphans.

The Verlainian cortège, since Verlain and Verlainian there are, stops at the entrance of a glass-covered passage, similar to many glass-covered passages, but more recent and better, naturally. Architecture, in disposition and clearness sufficient; elegance and low prices prices of Paris. This marvel modestly, or conceitedly, entitles itself, in French and in Dutch as you will, " Le Passage," and has no other name of a great man or of a locality at the tail end.

At the center of this illustrious passage exists a certain liquor-shop, Schiedam, well frequented, although not very fine in appearance. This is our first station in " S'Gravenhage "— the devil take the interpretation, thirty-six times muddled up, of this terrible word! I think that any explanation which should not be a course in history would have no other result here than the labor of the excellent witches mentioned in Victor Hugo's " Cromwell," who " sing while making knots."

A few instants later we invade a sumptuous establishment, all flowers, all trees, all mirrors, all electricity, wherein a literal festival of Titans is served to us. The painter, Philip Zilcken, and I separate from the civilians and go into the distant country at the Hêlêne Villa—here again a name with which one should be allowed to sleep only out of doors· " Bezuidenhout," think of it, my friends!— where we are received by his wife, a Belgian, not worse, and even better, than a Parisian— excuse a wounded man—all simple, all good, with wit. She carries in her arms their dear little Renée, to whom quickly I write a sonnet.

Sleep soon overtakes me in the delicious and comfortable room at the second story, which is mine for the entire period of my sojourn here.

What a sleep !

CCCCLXXII.

Art is neither a bust, nor a head, nor a body; it is the mind, faith, passion, pain.

Joséphin Péladan.

CCCCLXXIII.

All art is ideographic.

Joséphin Péladan.

CCCCLXXIV.

Yes, it is beautiful because it is beautiful.

Guy de Maupassant.

CCCCLXXV.

Have genius! In art, talent is nothing.

Théodore de Banville.

CCCCLXXVI.

I do not know what morality in art is.

Francisque Sarcey.

CCCCLXXVII.

The Laocoon of Virgil! . . . I know one more terrible It is the one smothered and devoured by serpents issued from his own heart.

J. Barbey d'Aurévilly.

CCCCLXXVIII.

You shall see that artists will shed tears over the Orient's slavery as they have shed tears over the liberty of Greece, and for the same reason. The picturesque departs from everywhere.

J. Barbey d'Aurévilly.

CCCCLXXIX.

For Christian metaphysicians art is a laughable effort of impotents.

Ibid.

CCCCLXXX.

Art is an embracing of clouds.

Ibid.

CCCCLXXXI.

Let a man be slightly a Christian with an ideal, and he shall have a better vision of the beautiful by closing his eyes like Milton than by painting with the divine brush of Correggio.

Ibid.

CCCCLXXXII.

There is no reason for not admiring Correggio.

J. Barbey d'Aurévilly.

CCCCLXXXIII.

There is something better than to have portraits and medals; it is to have none.

Ibid.

CCCCLXXXIV.

These devils of painters disconcert imagination.

Ibid.

CCCCLXXXV.

Gambling has diamond nails. It is terrible. It gives, when it wishes, misery and shame; that is why it is adored. The attraction of danger is at the basis of all great passions. There is no voluptuousness without vertigo. Pleasure mixed with fear intoxicates. Gambling is dumb, blind, and deaf. It can do

everything. It is a god. Those whom it cruelly despoils accuse themselves, not gambling.

Anatole France.

CCCCLXXXVI.

Æsthetics rests on nothing solid. It is a castle in the air.

Ibid.

CCCCLXXXVII.

There is no ethics.

Ibid.

CCCCLXXXVIII.

My feebleness is dear to me. I hold to my imperfection as to my reason for being.

Ibid.

CCCCLXXXIX.

Is there an impartial history? And what is history? A written representation of past

events. But what is an event? History is not a science, but an art.

Anatole France.

CCCCXC.

Old people care too much for their ideas. That is why the natives of the Fiji Islands kill their parents when they are old. Thus they facilitate evolution, whereas we retard its march by forming academies.

Ibid.

CCCCXCI.

Evil is necessary. If it did not exist, the good would not exist. Evil is the unique reason for the good's being. What would courage be far from peril? and what pity without pain? What would become of devotion and sacrifice if happiness were universal? It is because of evil and of suffering that the earth may be inhabited and that life is worth living. Do not complain of the devil. He is a great artist and very learned. For every vice that you destroy there was a corresponding virtue which perished with it.

Ibid.

CCCCXCII.

DIGRESSION. BY PAUL VERLAINE.

It is nine o'clock in the morning. As I look out of the window I verify the existence around me of water and of lawns studded with cows and windmills. The windmills are used to raise excess of water into superior canals, which generally flow into the sea through some great river.

We take breakfast with tea, in the English fashion, in a light and gay dining-room, full of sketches and of drawings of friends. I admire a Méryon, a vessel sailing into the unknown. Ancient clocks of the purest Dutch style mark and ring the hours.

Opposite the entrance to Hélène Villa, on the other side of the canal, the royal winter palace is seen from the rear. It is not beautiful, that palace. Big buildings of red brick and an odd dome with a round sun-dial. It is here that the Queen of the Netherlands comes to stay every winter.

What is beautiful is the immense park composed of centenarian trees, in this season all

red and gold under the sun, still warm in the beginning of a temperate November.

Legend says that Voltaire has promenaded among the mysterious shades of this wood cares, wherein philosophy had little part.

We pass into the studio, a studio as amusing as possible. No paintings The master has sent all his works to a great exhibition at Amsterdam. I look at the library consisting of works of Goncourt, two or three of Villiers, a number of technical works, some by Barbey d'Aurévilly, and . . . some Verlaine books. Then an infinite collection of exotic shoes. It is very amusing, and we are enjoying the spectacle when somebody rings, and here comes one of our companions, Jan Vetch, a friend of Zilcken, who sketches me while I begin to put on paper some notes for my first lecture.

" Ladies and Gentlemen : "

He has no sooner finished his work than Zilcken himself, armed with a kodak, takes my portrait under various aspects, seated and working.

" In the first place, I bow to this beautiful

land of Holland, to this land, this must be said now or never, the classic land of liberty under the magnificent despot Louis XIV. and his feeble successors, under the revolutionary dictatorship, then military, which was happily mitigated by the wisdom of the brother of the all-powerful emperor, that Louis Bonaparte who was something himself and leaves a name independent of his too graceful wife and of his tragic and too unfortunate son."

Zilcken will not let me go and beautiful phrases continue. . .

Somebody rings. . . . Shall I say happily? Again, one of last night's accomplices, Toorop, a symbolist painter. He is accompanied by Albert Verwey, a poet of great renown in Holland.

I continue.

"No, mesdames, no messieurs, the Roman school of which I am not the apostle, God preserve me from this! is not the ridiculous thing that people think. Moreas writes verses better than anybody and knows how to put in his rhythms something more than harmony. As for his disciples, all five of them have talent

that is becoming more and more original. As for the formula of this school . . ."

A maid knocks at the door and enters . . . must I say happily?—I say it—announcing that breakfast is served.

We sit at a table to which we do honor. I forget my lecture and think only of the ladies, talking with Mme. Zilcken and her mother, of Brussels, of Paris, and of laces.

At times I talk to Verwey, who expresses himself with difficulty in our language, which he knows thoroughly. He is all hair, this Verwey.

It is even the most terrible thing in his physicgnomy marked with true, almost infantile, kindness. Anyway, he is quite young, thirty years at most, which he does not wear.

Miss Renée is full of grace, the "patron" is nervous like the devil, we are all very gay, and to accompany our appetite a song bird of Holland throws at us its most successful trills.

After breakfast, coffee in the parlor. A good hour of doing nothing, entertained by these Batavian or Javanese cigars, which one should not smoke too much, under pain of

headache—especially when united, as they are frequently in this land of cold heads, to Schiedam bitters. But for a good Frenchman of France it's bad. So I abstained. I abstained during the entire time of my sojourn, otherwise how could I have given my lectures?

We return to the studio, where I put the last touch to to-night's lecture under the eye of an instantaneous machine vaguely fixed on me.

But the master declares that we must go to the city. I ask, as you may think, nothing better. Anyway my lecture is ready.

Was it the day that it rained so much or the one which was so beautiful? I do not remember; but the trees of the wood were more splendid—red, black, and gold, along the canal gilded by their reflection—than ever. To wait for the little tramway car did not take long. And we passed between two rows of houses with terraces, cornices, bay windows too English but coquettish, and take on our way a painter of talent, Etienne Bosch. We arrived after a short time at the heart of the city. The time to say good-evening to Blok in his book-shop and to stop for a moment in a

Bodega—and we go to visit the hall where I am to talk to-night. It is one of the rooms which compose the building of the Masonic Hall at The Hague. It has a doubly Protestant air. Walls painted in light green or something analogous, gray, or light red, my memory is at fault. No gold, no ornament. For furniture, a chandelier of bronze, a hundred chairs, a chair or a tribune in a corner. At the center a platform with the traditional table covered with green cloth, two candles and a glass . . . empty.

I ascend the platform, and not having my lecture with me I read, to try the acoustics, a paragraph from the *Gil Blas* in these terms ·

"Observed among our most elegant demimondaines, Berthe d'Egreville, Marion Delorme, Clêmence de Pibrac, Lêona Bindler . "

Oh, Calvin; oh, Frederic Passy; oh, Jules Simon; oh, immortal Senator Beranger! What say you of the bandit who comes to awaken these chaste echoes with names so charming! The voice is feeble. It is true, for my excuse to the saints whom I have cited, that the nec-

essary enthusiasm was lacking in my enumeration, but the acoustic is good.

Pretty as it can be, the city; Flemish houses, beautiful stores. The little pavement of brick is soft to the foot and gay to the eye. Few monuments: a city hall, very small, of the beginning of the Renaissance. with charming chimes. A palace for the various tribunals, small also and of an architecture pseudo-Gothic, I fear it is "perpendicularist" like the English cathedrals, but only one story high, which does not suit the style of architecture, which is really grand when lithe. See Westminster Abbey, Canterbury, so many other marvels. The churches of The Hague have nothing remarkable in their appearance. One Sunday, fourteen days after my arrival, I wanted to go to divine service in a vast building, all brick-red and mediæval glasses, but friends dissuaded me from going in, because when once you are in one of these temples you cannot get out until the end of the sermon.

And we go to the coffee-house. All in glasses and mirrors, this coffee-house, like that of the "Passage," trees and chrysanthemums.

The coffee-houses here recall those of Paris, but they are larger. People drink and smoke in them, and eat small, salted dry cakes. Those who wish to read the newspapers and the reviews may enjoy long tables in one of the most luminous corners of the establishment. But the dinner-hour rings, and a magnificent quasi-carriage takes us back to Hélène Villa. Along the route, in spite of the cigars, we talk. My host is a type, the finished type of a stranger talking French as well as you or me, without any accent and without a fault, the type of an artist knowing a thousand things, varied, instructive, and incisive in his conversation, and whom one would listen to forever. The son of a high clerk of the government, he was in his youth the private secretary to Queen Sophie, the only friend of the unfortunate Napoleon III., who, if he had listened to her, would have spared us the war of 1870. Physically, Zilcken does not at all look like the idea that one forms of a Dutchman—from the Flemish painters, from also literature. The classic tobacco-pot gives place in him to a tall young man, thin, lithe, always in motion. He has a

great reputation as a painter and as an engraver in this country, and is not unknown to our national exhibitions.

We are at Hêlêne Villa. I go up-stairs " to dress," I come down to take notes and books—and we start for glory in a hired carriage which will bring us back at a late hour. Madame Zilcken has not forgotten to carry an egg that the lecturer will swallow for his voice, but here is the fearful cavern with endless corridors, with innumerable rooms more austere than any which you have ever seen. I swallow the egg and I make my entrance in the hall. A good hundred in the audience, among whom are many ladies and young girls, who greet me with plaudits. I ascend the three steps of the platform and take my seat between two candles, with, at my right, the glass of water, a sugar-bowl, a decanter, while Zilcken puts on the table a pile of books, all my works, the poems of the Roman school, others, all the poems to be carefully analyzed marked with long pieces of white pape.

I begin.

I had not spoken until then more than once

in my life. It happened in 1869. This is how it happened. I had, in combination with a friend, indorsed the note of a Polish exile for a loan of several hundred francs. The hero in question having soon after quitted sweet France one fine morning, something imperative came to me signed by a justice of the peace. I arrived before him at the appointed day, and when the magistrate asked me what I had to say, I exclaimed, " Adjourn for eight days." This was accorded. What became of this success in oratory? I did not appear in eight days, and I think I am still a debtor for the loan to the martyr.

But this precedent twice triumphant was not of a nature to reassure me. And I tremble a little when I pronounce the sacramental " Ladies, Gentlemen," followed by a bow in the Holland fashion. The depth of my thought was, you do not doubt it, that I would like to have finished. Happily I had arranged, while coming, a gentle little phrase about The Hague in particular, " this truly royal city, where ease and comfort," etc. It was very successful, and so I could attack my subject less timidly. I

talked minutely of contemporary poetry, going back to Romanticism and arriving at contemporary Parnassus, to which I paid due homage. Then I analyzed, I explained, in the best way that I could, the shades of decadism and of symbolism and the mysteries of the Roman school, summarizing the whole by a solemn good-night to all these abstruse words— which happily do not take talent away from those who have it, although it pleases them to dress themselves in the showy costumes. And I cited, in support of my thesis, great lots of verses of my comrades and friends, whom I had the happiness of causing to be applauded frequently.

After which I spoke of myself, making of my biography, which would be so complex for one who undertook it seriously, a summary discreet but sincere. And I read verses of mine—fragments of " Sagesse," which pleased the audience.

It was a suçcess. Only three things were criticised: My voice was a little veiled, I had not principally quoted my own verses, I had recited my lesson without taking time to rest

and to give time to my audience to rest for a quarter of an hour, as is the custom here.

But here come Zilcken and Madame Zilcken, Toorop, Verwey, who take me to the Passage, where we invade a large coffee-house.

CCCCXCIII.

Most disputes about art are disputes about definitions.

Alfred de Musset.

CCCCXCIV.

A painter must be up with the dawn. The light of the sun is his life and the real element of his art, since he can do nothing without it.

Ibid.

CCCCXCV.

History has often talked of the facility with which great artists executed their works. Some have been quoted who knew how to unite with work disorder, and even laziness. But there is no greater error than this. It is not possible that a painter, well trained, sure of his hand and of his fame, may succeed in mak-

ing a beautiful sketch among distractions and pleasures. Vinci painted, they say, holding a lyre in one hand; but the celebrated portrait of the Joconda remained for five years on his easel. In spite of rare tricks which are always too vaunted, it is certain that the really beautiful is the work of time and that there is no real genius without patience.

Alfred de Musset.

CCCCXCVI.

The first sign of decadence in **art** is deplorable facility **in** work.

Ibid.

CCCCXCVII.

Invaded is the word, for the immense building which until now had no clients was crowded in an instant by people who, although Dutch, were noisy and talked about me—at least I dare to think that, plausibly, they talked of me.

Congratulations had already come to me when I came from the platform—congratulations too ardent, doubtless, but so visibly made

in good faith, and cordially, that they did me a real pleasure. These congratulations were mingled with too soft reproaches; one less than in the hall. It was that I had not made two parts of my lecture, and that I had read too little of my verses. This last criticism was made by students of Leyden and Amsterdam, who had come to invite me to lecture among them.

There were not in this concourse of literary men only students, amiable young men and others warmly communicative. I noticed among the crowd of this colossal coffee-house a man yet young, with a powerful and devastated face, who drank and smoked alone and dumb in solitude. I asked of a neighbor what this remarkable figure was. He answered as follows· "It is Willem Kloos, the divine, taciturn, extra nervous, and placid. Grand master of the literary movement in Holland. Has had an enormous influence by his criticisms in the *Nieuwe Gids;* began the war in 1883 by his famous introduction to the posthumous poems of Jacques Perk—died at 23; has written the most grandly beautiful poems of our literature.

"Maladive, often dead, but is immortal. Principal work · 'Het boek van Kind en God'—1889."

"In his first period Kloos had been influenced by Shelley, by Heine, and by Count Platen. He began by writing German verses, which were published in an obscure review that nobody knows.

"An irreducible temperament. Studied the classic letters; has a reputation for being learned in the Greek of Æschylus; has broken with university studies because he had not the ambition to give lessons for a living."

At this moment the one who had been the object of so interesting a communication arose from the table and came to me to introduce himself. We shook hands, and I profited from the information which I had received about him to talk of him and of his works. He replied in a French harsh but correct, very gracefully, in monosyllables, and nothing less than the coming of some of his Amsterdam companions, great drinkers and great smokers, could unwrinkle a little his noble head.

I say nothing of the great number of small

and of big glasses drunk, of little dry cakes munched, of cold food absorbed, and of cigars smoked. The conversation had become general, the women joining in it.

But hours fly, and to-morrow is not to be a day of rest.

The next morning I rise late. Verwey, who does not live at The Hague, had been invited. This circumstance recalled to my memory my conversation of the day before with this gentleman, so well informed about the men of letters of Holland, a conversation interrupted at the moment when he was to serve Verwey himself to me.

"Here," said Zilcken, "is a black book. But it contains some notes. Read this one among them:

"'Albert Verwey. Less genius, perhaps, but more talent than Kloos; his elder by six years. Has been the pupil, the child in art, and the very intimate friend of Kloos. Since has published in 1885 verses of great beauty and a "Van het leven" of life. In 1889 retired a little. Very precocious. At seventeen years of age he wrote an epic poem which

made a great flurry—" Persephone "—in an extraordinary rhythmic form.' "

A few moments later Verwey was there. The breakfast was gone over quickly, because we had to visit the museum, which was open only at certain hours. Verwey had an anxious air, turned around the room, touching art objects on the table and lighting his cigar. Finally he said, or rather, so discreet and timid he was, confessed, that he had composed verses about me And he improvised the following translation, which I copied. Here it is :

" His cranium was high, very pale, bow-shaped, his eyes, half closed, in a straight line, black, the nose of a little boy, a mouth hidden under a falling mustache, a chin hidden by a pointed beard. . . .

" Did his eyes, when they were open, laugh or cry ? "

These verses are beautiful, do you not think ? Verwey had read them to me in Dutch, and I found their music strange, their harmony new. For those who know me physically, there are realistic traits in the description which are

perfect. My nose, the nose of a little boy, is a cleverly caught trait.

I cordially thanked the poet and shook his hand warmly, when Zilcken exclaimed, " Hurry, if we are to arrive in time."

I do not know if it was the day which was so beautiful, or if it was the one when it rained so much, but the trees along the canal were more beautiful than ever, of a supreme beauty, but their red leaves, black **and** gold, had airs of mourning.

FINIS.

CPSIA information can be obtained at www.ICGtesting.com
Printed in the USA
LVOW10s0032190216

475705LV00024B/807/P